IMAGES
of Rail

SOUTH DAKOTA
RAILROADS

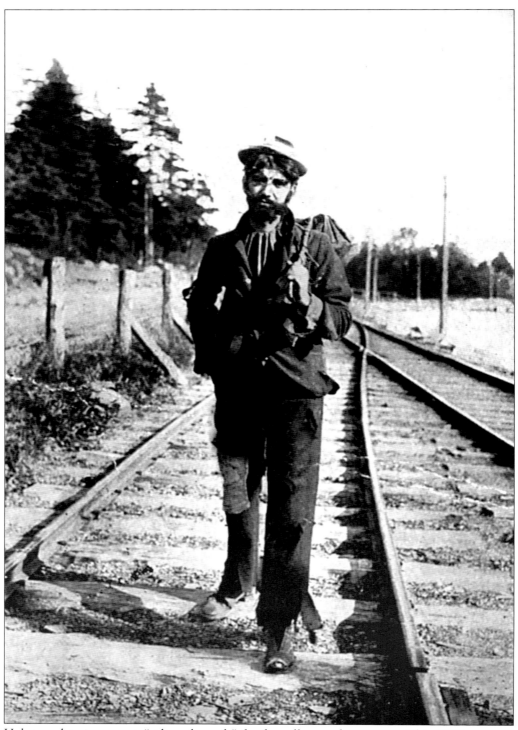

Hobos and trains meant "riding the rails" for free all over the country. This 1907 postcard mailed from Coleman, South Dakota shows a hobo with all his worldly processions.

IMAGES
of Rail

SOUTH DAKOTA
RAILROADS

Mike Wiese and Tom Hayes

ARCADIA
PUBLISHING

Published by Arcadia Publishing
Charleston SC, Chicago IL, Portsmouth NH, San Francisco CA

Printed in the United States of America

Library of Congress Catalog Card Number: 2004105912

For all general information contact Arcadia Publishing at:
Telephone 843-853-2070
Fax 843-853-0044
E-mail sales@arcadiapublishing.com
For customer service and orders:
Toll-Free 1-888-313-2665

Visit us on the Internet at www.arcadiapublishing.com

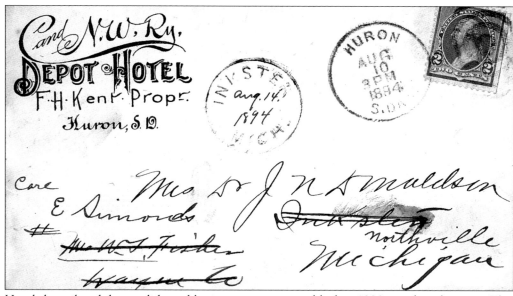

Hotels by railroad depots did good business as most travel before 1920 was done by train. This is stationary from the Canadian and North Western Railway Hotel in Huron in 1894. This railroad later became the Chicago and North Western.

CONTENTS

ACKNOWLEDGMENTS

The scenes depicted in this book reflect a bygone era of railroads and coal powered steam engines that now only exist in museums and as pictures in history books. It was a great time in America; trains were of vital importance to the economy of the nation and the survival of many small towns was dependant on the railroads stopping at their town and maintaining a depot there.

These memories are kept alive through the existence of the images contained in this book. Many people chose to share their love for trains and train travel through railroad postcards. This book contains many of these images. If there was an interesting message on the postcard, then we included it in the caption below the postcard. We have also included this mailing date in the description of those cards that were sent in order to establish a time period of when this postcard was made.

This book would not have been possible without the patience and understanding of our wife's while we were working on this book and their understanding of our collecting habits. I appreciate the many conversations I have had with Bob Lathrop and Isabel Brink about the railroads over the years. A special thanks to Sonny Decker for the Menno postcard and to Darrin Holien for his three Watertown postcards, all of which have added to this book.

INTRODUCTION

The railroad opened up millions of acres of government land in the west to expand the settlement of towns and farms in an ever-growing nation. Immigration to this country lured farmers from Europe and Easterners with the promise of cheap farmland. There was land to be had out west, and the railroads brought those looking for it by the thousands. They brought them to the towns that had been established as the railroad tracks were laid. Most people are unaware that it was also these railroad officials that usually gave these new towns their names; often naming them after familiar places. Aberdeen was named after the town in Scotland, and Scotland, South Dakota was named after the country. They named so many towns that they almost ran out of names.

The images in this book represent the period from 1907 to 1920 in South Dakota. During this period the railroads moved and sorted all of the mail on special cars on the train. They brought settlers west in anticipation of farmers shipping their crops and ranchers shipping livestock back east. And the railroads brought finished goods and equipment to the west. Empty boxcars do not earn any money, so it was hoped that shipping would be both ways. It was good business for the railroads to expand and open new markets.

Railroads employed a lot of people, both in the building of the railroads and the maintenance and servicing afterwards—railroad crews, depot agents, freight handlers, express agents, temporary help during the snows of winter, and help hired to clear the various derailments and train wrecks. Some towns had as many as 22 trains a day going through. This takes a lot of people and coordination. It was inevitable that there would be accidents and derailments that would shut down the trains until the tracks were cleared. So the railroads would have special crews and equipment to clear the tracks.

The following 12 railroads operated in South Dakota during the 1907 to 1920 period:

Chicago, Burlington and Quincy
Chicago, Milwaukee and Puget Sound
Chicago, Milwaukee and St. Paul
Chicago and North Western
Chicago, Rock Island and Pacific
Chicago, St. Paul, Minnesota and Omaha
Great Northern
Illinois Central
Minneapolis and St. Louis
Minnesota, St. Paul and Sault Ste Marie
South Dakota Central
Wyoming and Missouri River

The authors hope that you will enjoy this book, its varied subject matter, and each caption. In our research, we have tried to be accurate, but after so many years, some errors just keep on repeating themselves.

One

DEPOTS

A depot in town ensured the area's survival and growth. Depot towns had an economic advantage over towns where the railroads didn't stop. Small towns with passenger service afforded residents with opportunities. They were able to visit the doctor, go to other towns, shop, visit, and ship their five-gallon milk cans with a ready outlet for crops and livestock. Merchants were able to obtain a steady supply of goods. At one time, the whole nation was geared to ship and receive everything by railroads in a timely manner.

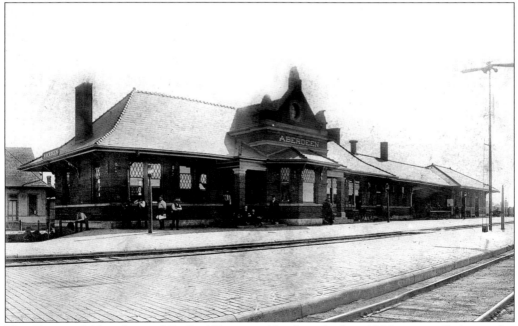

The Chicago, Milwaukee and St. Paul Depot in Aberdeen, built in 1904, was totally lost to fire on January 23, 1911.

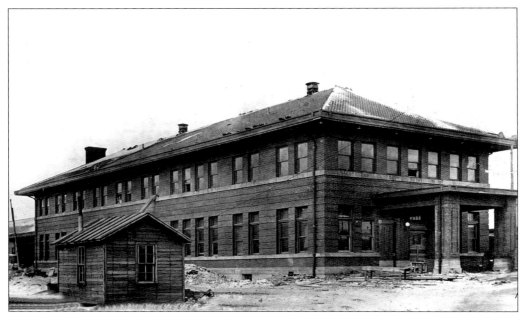

The new Chicago, Milwaukee and St. Paul Depot opened in December 1911 to replace the depot that was destroyed by fire on January 23, 1911.

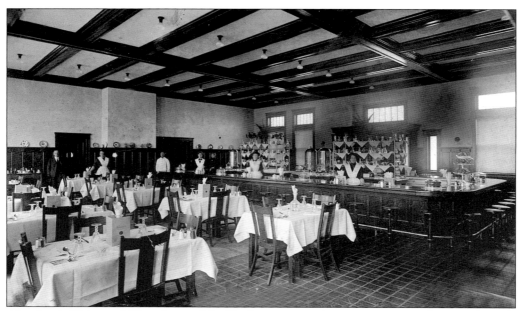

Aberdeen's Chicago, Milwaukee and St. Paul's inter-state dining room is seen here in the new depot that was completed in 1911. This depot became famous during World War II for giving out pheasant sandwiches to all the military personal passing through Aberdeen on Troop Trains.

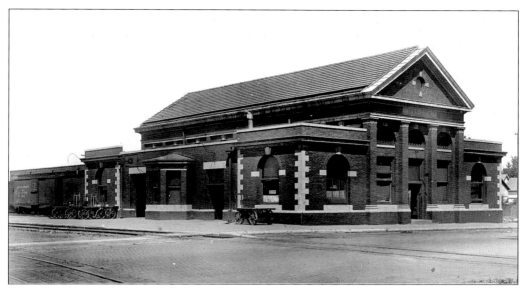

The Minneapolis and St. Louis Depot opened in 1907 and the tracks were extended to Leola from Aberdeen, thereby ending the Aberdeen & Leola Stage Line, the last stage company in Northeastern South Dakota.

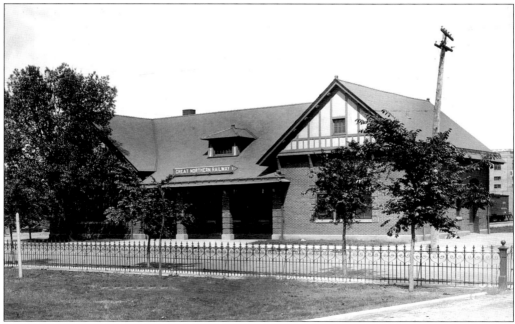

This is the Great Northern Depot in Aberdeen. In addition to their regular timetable, they also ran excursion trains to Tacoma Park, a local recreation sport just northeast of town. This is the current home of the Law Offices of Richardson Wyly, Wise, Sauck and Hieb. This card was postmarked September 1, 1912.

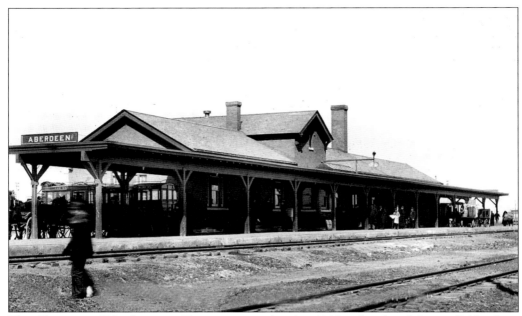

This Chicago and Northwestern Depot was completed in 1910 and replaced the small Aberdeen depot that was moved to Crandon, South Dakota. It is the current home of Health Care Plus Federal Credit Union.

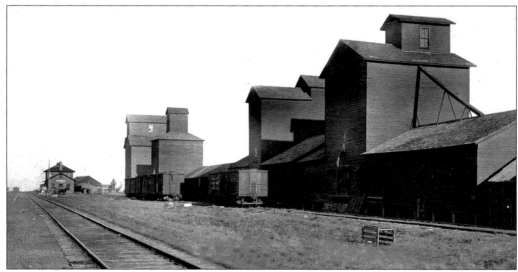

The Chicago, Milwaukee and St. Paul Railway Yards in Alexandria, Hanson County are seen here. The depot is in the distance on the left. This postcard was postmarked April 25, 1908 and the message talks of fruit trees arriving the day before by rail freight.

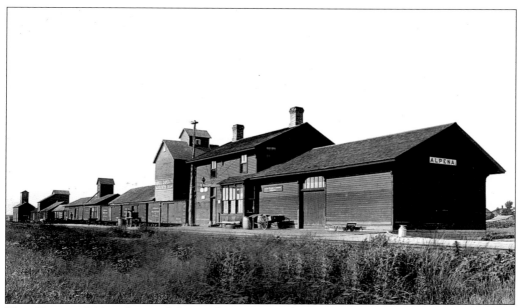

The Chicago, Milwaukee and St. Paul Depot, warehouses, and elevators in Alpena, Jerauld County, are pictured here *c.* 1910.

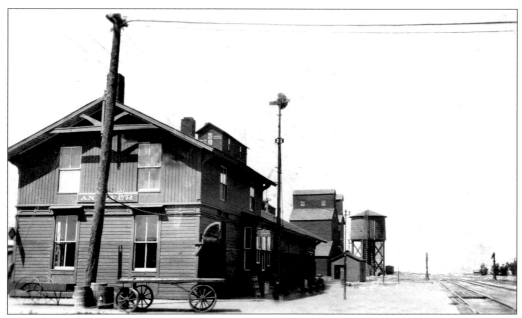

The Chicago, Milwaukee and St. Paul Depot in Andover, Day County, is seen with a nice picture of the water tank. Postmarked August 25, 1916, the sender had just gotten a job in Andover.

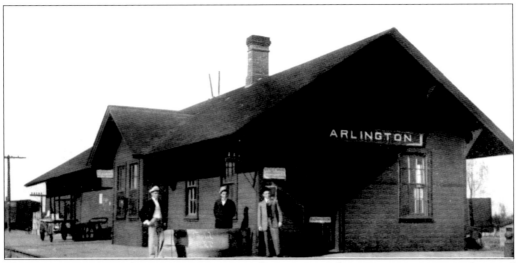

The Chicago and North Western Depot in Arlington, Kingsbury County is seen in this card postmarked July 26, 1909.

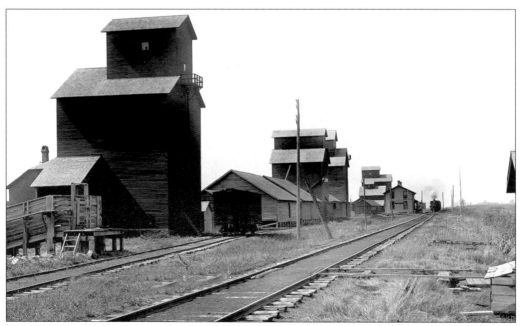

The Chicago, Milwaukee and St. Paul Depot and Elevator Row in Artesian, Sanborn County, is pictured here *c.* 1910.

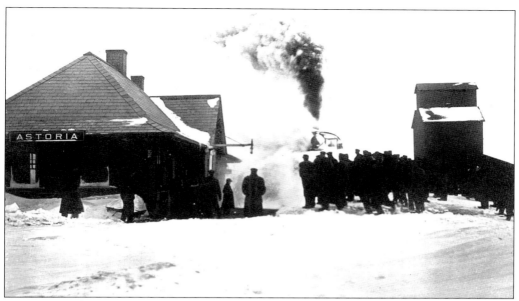

Astoria, Deuel County, home to the Chicago, Rock Island and Pacific Depot is visible in this postcard which shows a rotary snowplow on January 22, 1910.

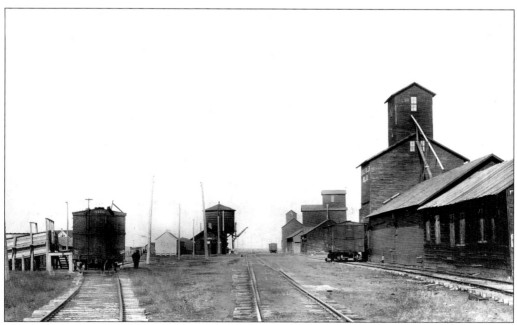

Athol, Spink County, was home to the Chicago and North Western Depot, at right. This image, postmarked July 21, 1915, shows the railroad yard, water tank, and elevators.

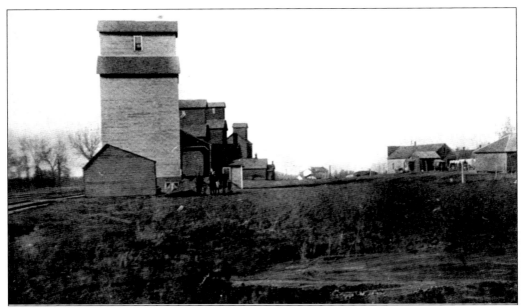

The Chicago, Milwaukee and St. Paul Railroad Yards in Baltic, Minnehaha County, is seen here c. 1909.

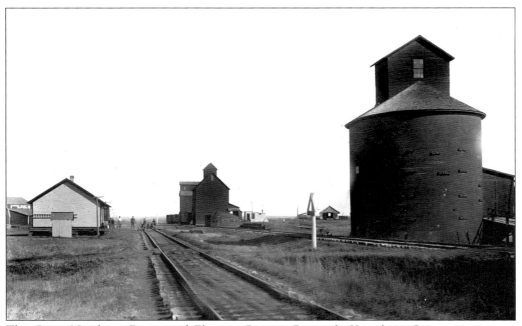

The Great Northern Depot and Elevator Row in Bancroft, Kingsbury County is seen on this card postmarked August 30, 1917. The message talks of bringing a load of oats to the elevator for shipping.

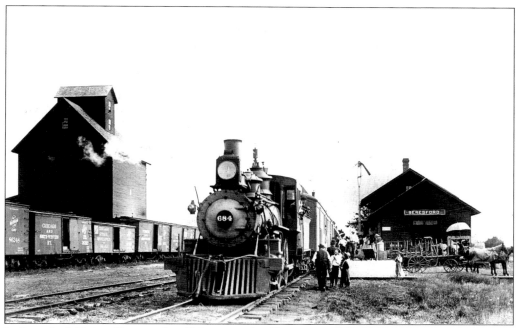

In Beresford, Union County, this 684 train at the Chicago and North Western Depot is pictured loading or unloading freight in horse drawn wagons, *c.* 1910.

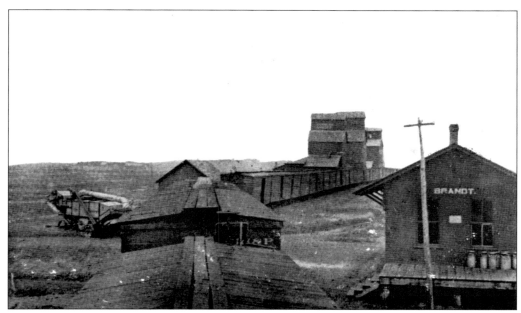

The Chicago, Rock Island and Pacific Depot and elevators in Brandt, Deuel County, is seen here *c.* 1909.

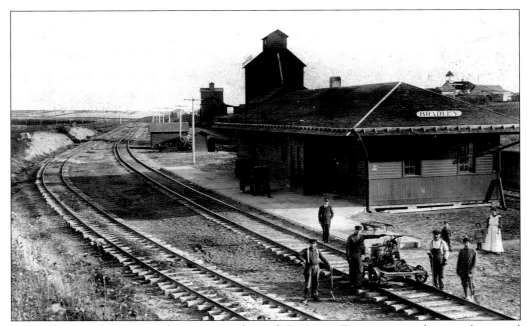

In Bradley, Clark County, the Minneapolis and St. Louis Depot is seen here with several workers and a handcar in the foreground, *c.* 1910.

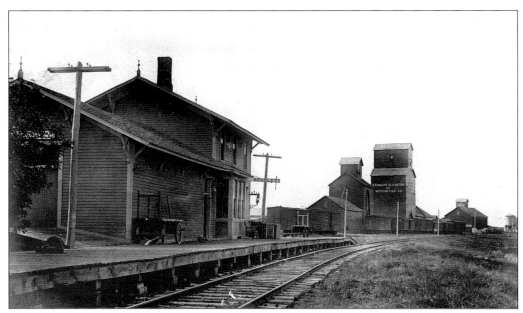

The Minneapolis and St. Louis Depot and Elevator Row in Bradley, Clark County, are visible in this card postmarked November 8, 1910.

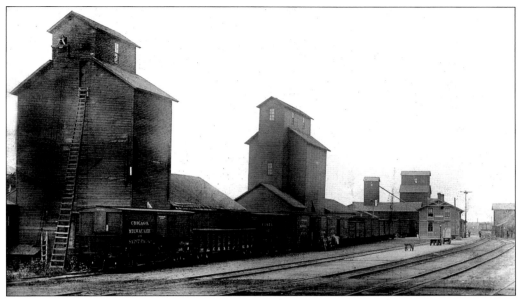

The Chicago, Milwaukee and St. Paul Depot and elevators in Bristol, Day County, are seen here *c.* 1910.

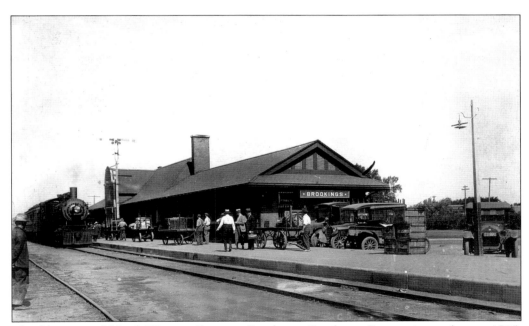

The Chicago and North Western Depot in Brookings, Brookings County, is seen here *c.* 1915. The message informs the receiver that they will be arriving on the Wednesday morning train.

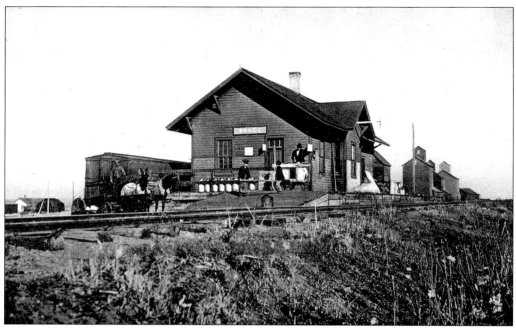

The Chicago and North Western Depot and elevators in Bruce, Brookings County, is pictured here c. 1915. Notice the five-gallon milk containers that are ready for shipping.

The Chicago, Milwaukee and St. Paul Depot and elevators in Bryant, Hamlin County, are pictured here c. 1915. The depot is in the far center.

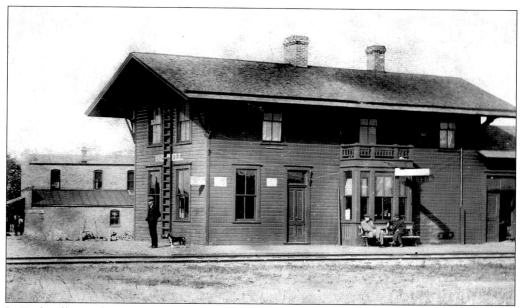

In Bushnell, Brookings County, the Chicago and North Western Depot is pictured in this card postmarked May 19, 1910.

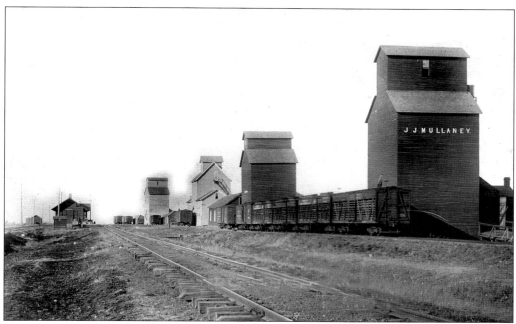

The Chicago and North Western Depot and elevators in Canova, Miner County are seen here. The depot is on the left. This picture postcard is postmarked January 13, 1910.

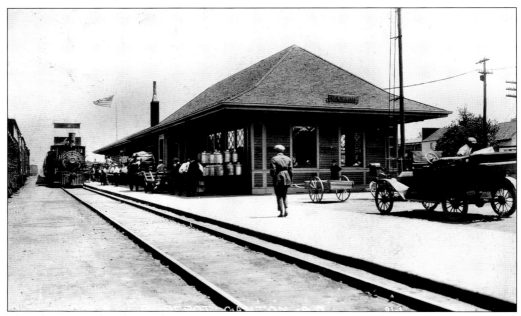

The Chicago, Milwaukee and St. Paul Depot in Canton, Lincoln County, is seen here *c.* 1910.

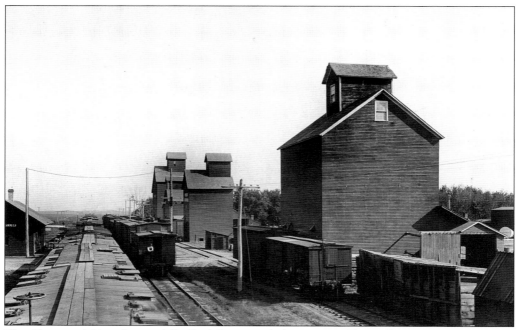

The Chicago, Milwaukee and St. Paul Depot and elevators in Chancellor, Turner County, are pictured here *c.* 1910.

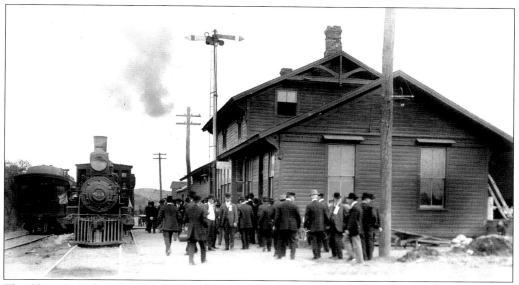

The Chicago, Milwaukee and St. Paul Depot and passenger station in Chamberlain, Brule County, are seen here *c.* 1910. Notice that all the men are wearing hats, a custom now long forgotten.

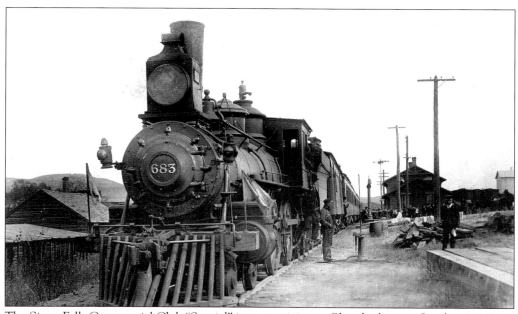

The Sioux Falls Commercial Club "Special" is seen arriving at Chamberlain on October 14, 1907.

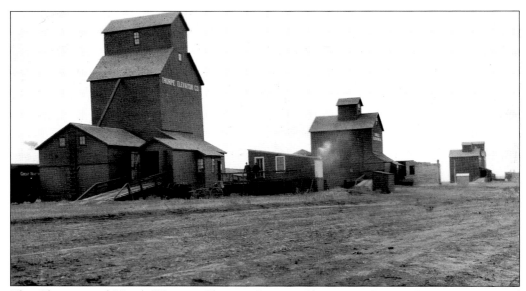

The Chicago and North Western Elevator Row in Claremont, Brown County, is pictured here *c.* 1910.

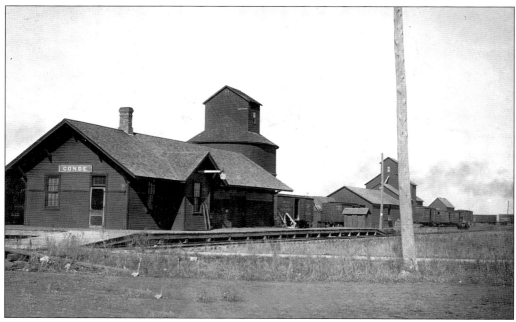

The Chicago and North Western Depot and elevators in Conde, Spink County, are shown here *c.* 1910.

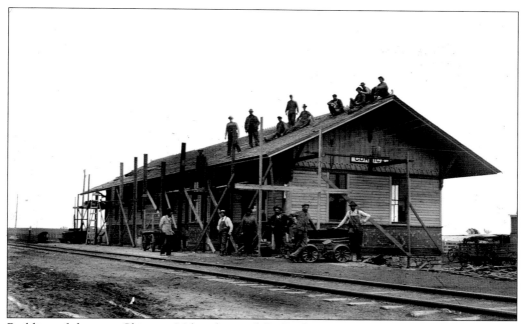

Building of the new Chicago, Milwaukee and St. Paul Depot in Corsica, Douglas County, is evident in this image *c.* 1908.

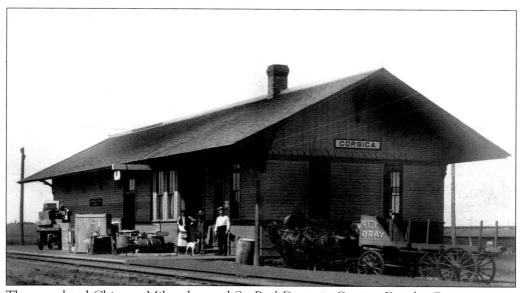

The completed Chicago, Milwaukee and St. Paul Depot in Corsica, Douglas County, is seen here in this *c.* 1908 image.

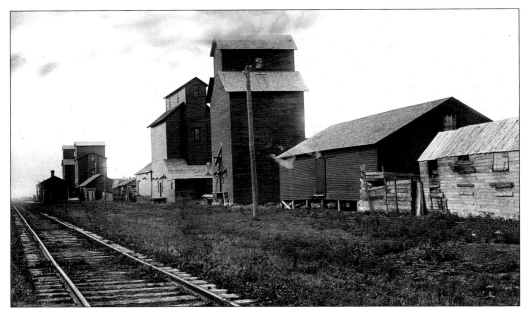

The Chicago, Milwaukee and St. Paul Depot and elevators in Corona, Roberts County are seen in this photo postcard, postmarked September 15, 1908. The depot is on the far left.

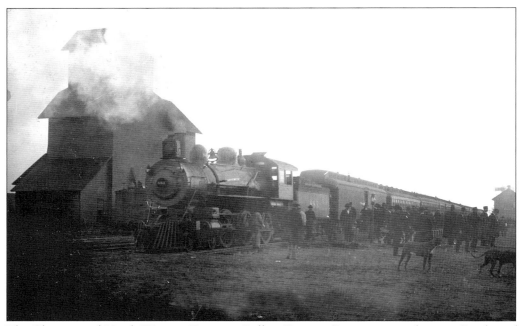

The Chicago and North Western Depot in Dallas, Gregory County, is seen here in October of 1908 with engine 883 and train.

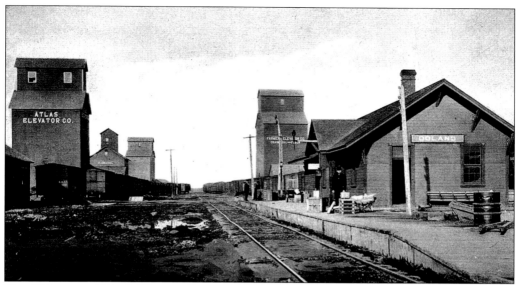

The Chicago and North Western Depot and Railroad Yards in Doland, Spink County, are seen here *c.* 1910.

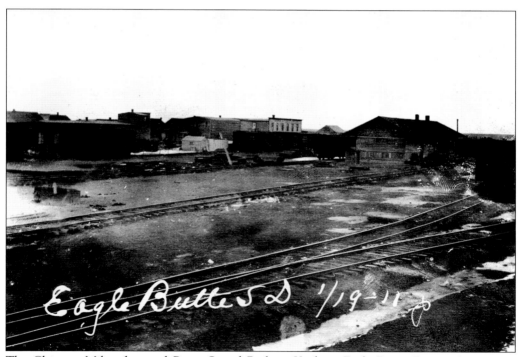

The Chicago, Milwaukee and Puget Sound Railway Yards in Eagle Butte, Dewey County are pictured on January 19, 1911. The message on the side states, "One of my many stopping places".

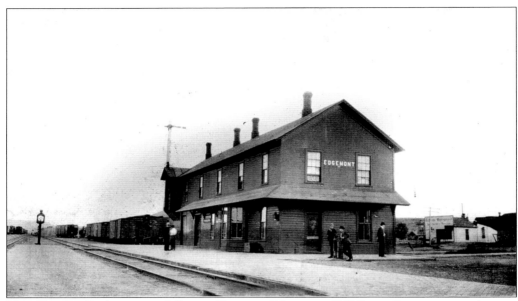

The Chicago, Burlington and Quincy Depot in Edgemont, Fall River County is seen here in this card postmarked August 1, 1912.

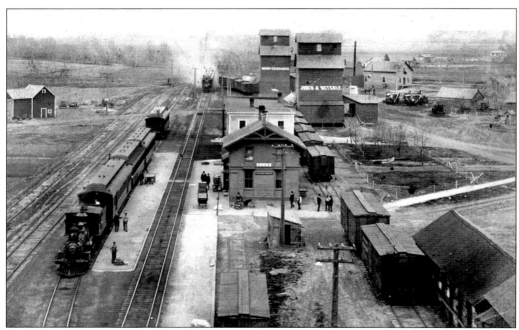

This image taken in Egan, Moody County, shows the Chicago, Milwaukee and St. Paul Depot and Railroad Yards with one train on a sidetrack while another train is coming on the main line. This card was postmarked August 15, 1908.

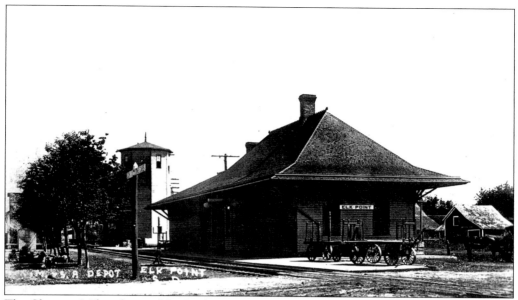

The Chicago, Milwaukee and St. Paul Depot is seen here in Elk Point, Union County, *c.* 1908.

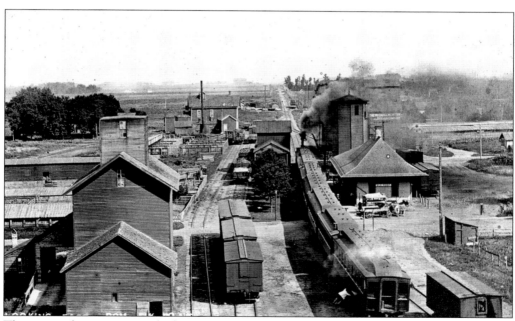

This image features a view looking east into the Chicago, Milwaukee and St. Paul Railroad Yards in Elk Point, *c.* 1915, and shows the depot at the right and the elevators and stockyards at the left.

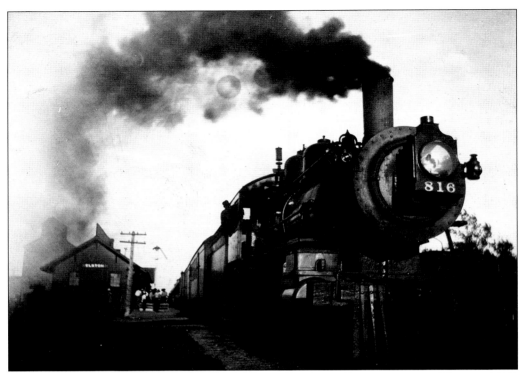

The Chicago and North Western Depot in Elkton, Brookings County, is pictured here *c.* 1910, with engine 816 and train. This is a good picture of a "cow catcher" on the front of the engine.

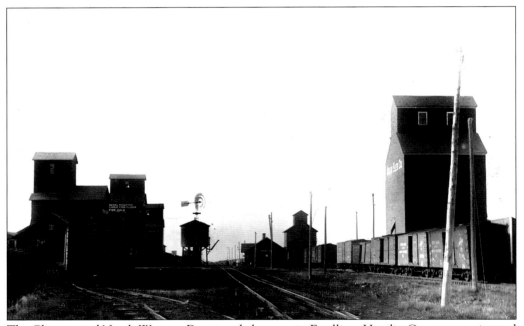

The Chicago and North Western Depot and elevators in Estelline, Hamlin County, are pictured here *c.* 1915. This is a nice example of a windmill supplying the water tank.

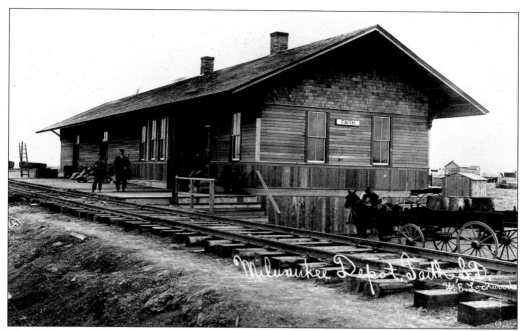

The Chicago, Milwaukee and Puget Sound Depot in Faith, Meade County is visible in this image postmarked April 15, 1911. The sender had just brought 20 dozen eggs to Faith and sold them for 20 cents a dozen.

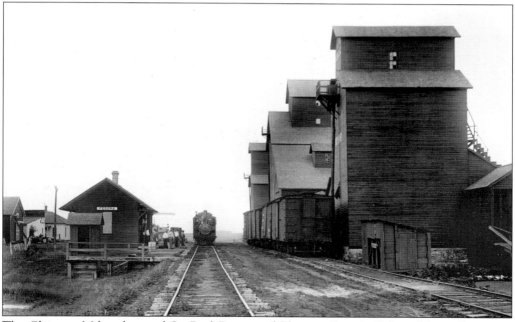

The Chicago, Milwaukee and St. Paul Depot and Elevator Row in Fedora, Miner County, is pictured here c. 1910.

This image shows the start of the Chicago Milwaukee and Puget Sound Depot in Firesteel, Dewey County, c. 1910. The message talks about family members having typhoid fever and coming close to losing one of them.

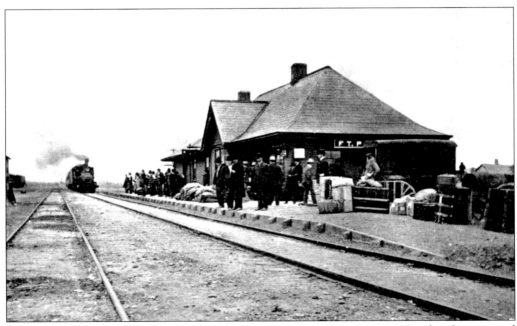

Pictured here are the Chicago and North Western Depot in Fort Pierre, Stanley County, and the first train arriving there on October 14, 1907.

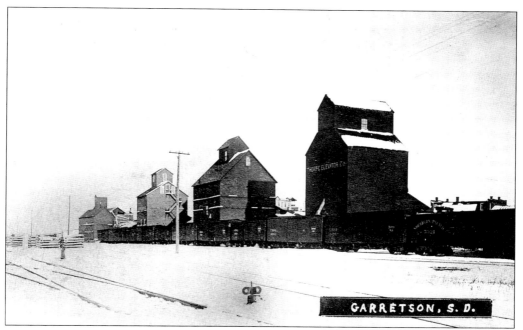

The Great Northern Railroad Yards and Elevator Row in Garretson, Minnehaha County, are seen here *c*. 1910.

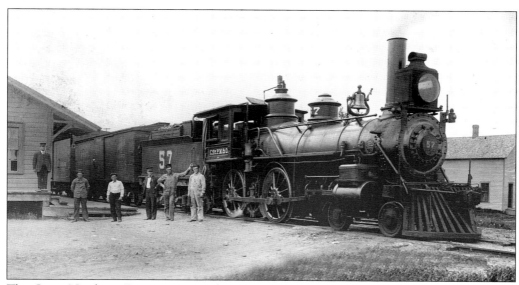

The Great Northern Depot is pictured in Garretson with the "on time" crew and engine 57 from the Chicago, St. Paul, Minnesota and Omaha line.

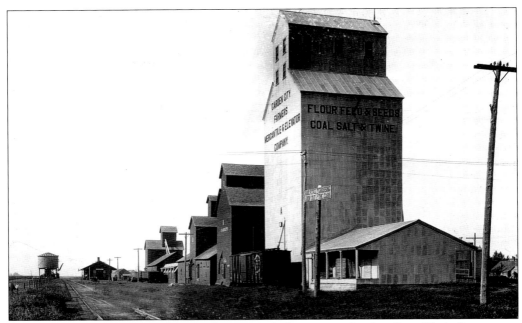

The Chicago, Milwaukee and St. Paul Depot and elevators in Garden City, Clark County, are seen here *c.* 1915.

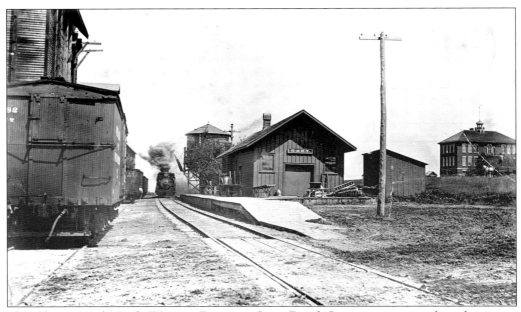

The Chicago and North Western Depot in Gary, Deuel County are pictured in this image postmarked February 11, 1911.

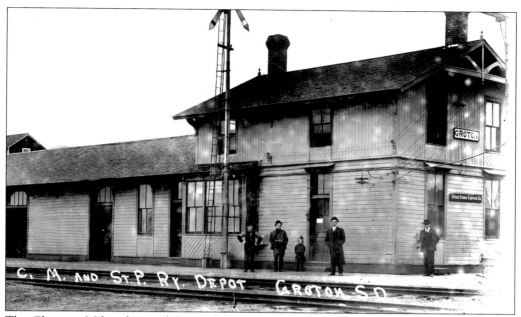

The Chicago, Milwaukee and St. Paul Depot in Groton, Brown County is seen here in this postcard sent on January 7, 1909.

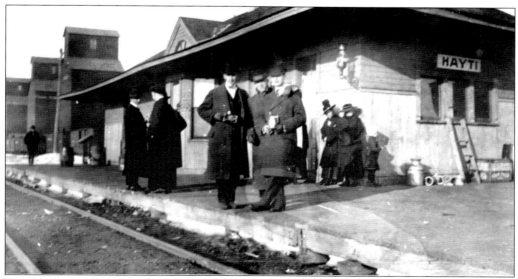

The South Dakota Central Depot in Hayti, Hamlin County, is pictured here c. 1910.

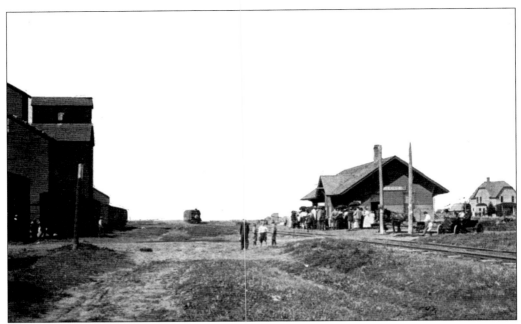

The Chicago and North Western Depot in Hecla, Brown County is pictured in this card sent August 6, 1911.

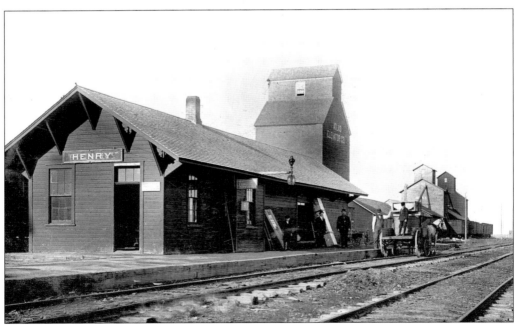

The Chicago and North Western Depot and elevators in Henry, Codington County, are pictured c. 1908.

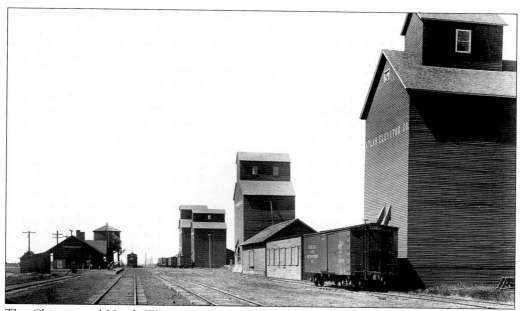

The Chicago and North Western Depot and Elevator Row in Hitchcock, Beadle County, is seen here *c.* 1908.

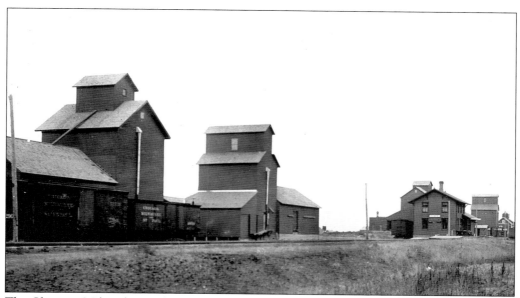

The Chicago, Milwaukee and St. Paul Depot and Elevator Row in Hosmer, Edmunds County, are pictured here *c.* 1908.

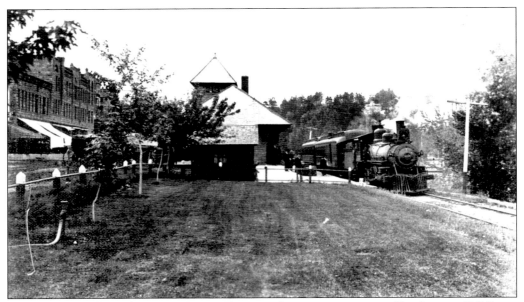

The Chicago and North Western Union Depot and passenger station in Hot Springs, Fall River County is visible in this image. Postmarked February 23, 1911, this card informs the addressee of his train schedule to arrive in Ohio.

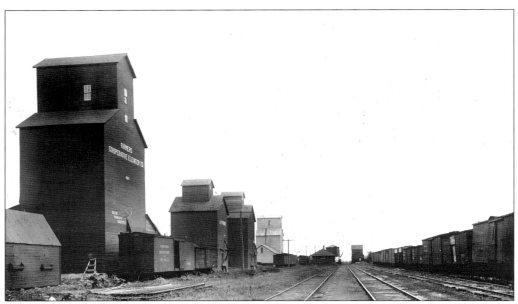

The Chicago, Milwaukee and St. Paul Depot and Elevator Row in Hudson, Lincoln County, are pictured here *c.* 1910.

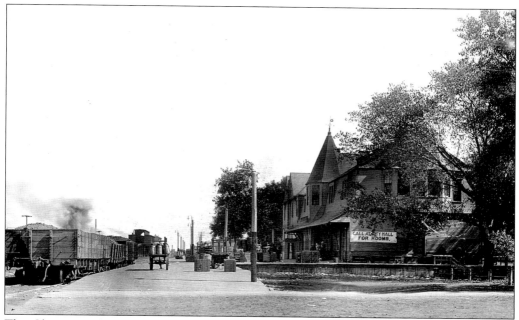

The Chicago and North Western Depot in Huron, Beadle County is featured here in this image. The postmark is September 15, 1914 while at the state fair and says that "1175 people were on this train for the State Fair".

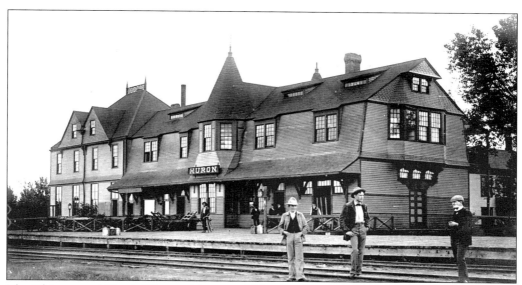

The Chicago and North Western Depot and Hotel in Huron, are shown here c. 1915. Actual depot hotels were a rarity in South Dakota.

The Chicago and North Western Freight Depot in Huron is seen in this image postmarked September 10, 1914.

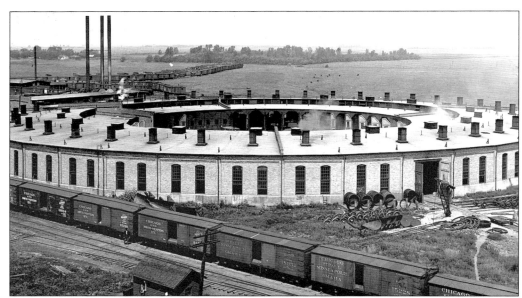

The Chicago and North Western Roundhouse in Huron is visible in this photo copyrighted 1909 and postmarked November 20, 1909.

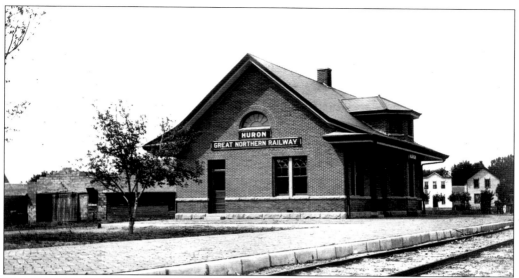

The Great Northern Depot in Huron, Beadle County, is seen here *c.* 1915.

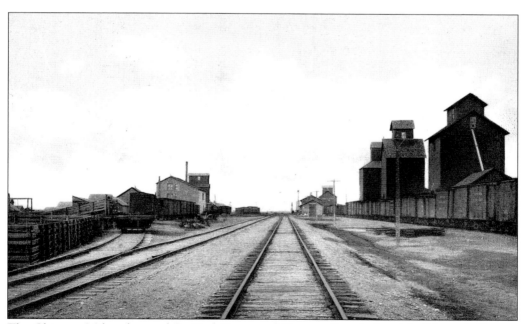

The Chicago, Milwaukee and St. Paul Depot and Elevator Row in Ipswich, Edmunds County is shown in this image, postmarked September 18, 1914 with message that "this is a view looking west".

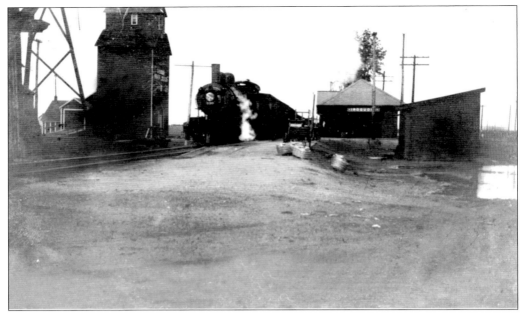

The Chicago and North Western Depot in Iroquois, Kingsbury County is seen in this image with a postmark of October 22, 1912.

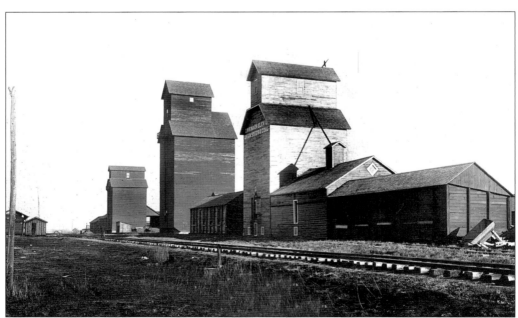

Elevators in the railroad yard in Junius, Lake County are seen here. The Chicago, Milwaukee and St. Paul Depot is the building on the far left. Trains delivered a lot of coal to South Dakota, as this was the primary source of heat in a state without trees.

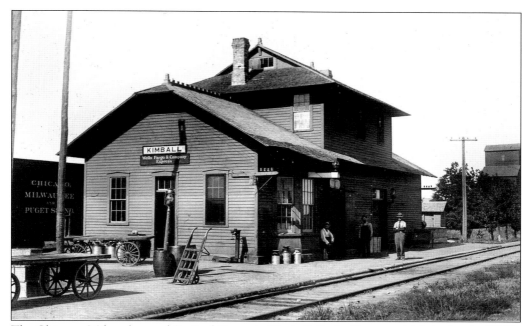

The Chicago, Milwaukee and St. Paul Depot in Kimball, Brule County, which is also the Wells, Fargo and Co. Express Office, is featured in this image postmarked December 4, 1912.

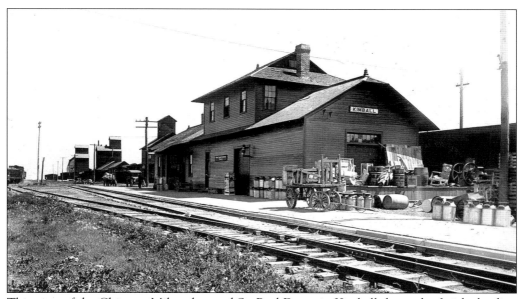

This view of the Chicago, Milwaukee and St. Paul Depot in Kimball shows the freight loading dock, *c.* 1915.

The Minneapolis and St. Louis Depot and elevator in Kampeska, Codington County, are seen here *c.*. 1910. (Courtesy of Darrin Holien.)

The Chicago, Milwaukee and St. Paul Depot and elevators in Lane, Jerauld County, are seen here *c.* 1910.

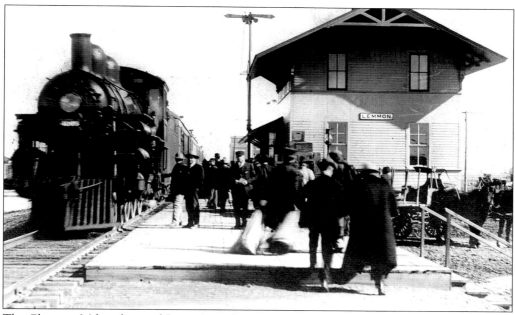

The Chicago, Milwaukee and Puget Sound Depot in Lemmon, Perkins County is featured here with a postmark of July 2, 1909.

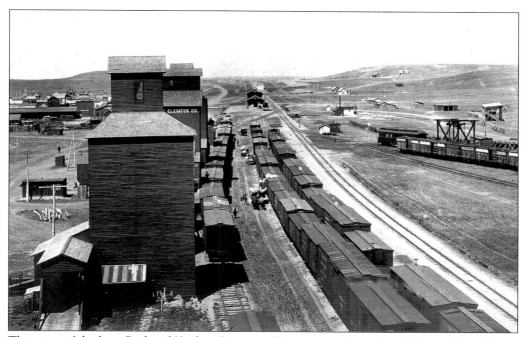

This view of the busy Railroad Yards at Lemmon shows one main track and three side tracks on either side. The depot is in the far center. Postmark is September 8, 1909.

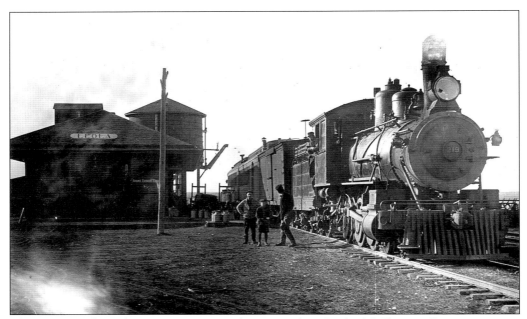

The Minneapolis and St. Louis Depot and water tank in Leola, McPherson County, are seen here *c*. 1910.

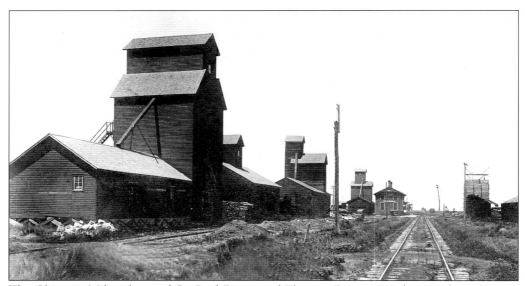

The Chicago, Milwaukee and St. Paul Depot and Elevator Row in Letcher, Sanborn County are visible in this image postmarked July 23, 1907.

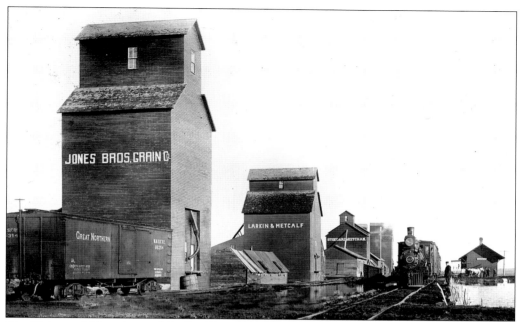

The Chicago, Milwaukee and St. Paul Depot and Elevator Row in Lily, Day County are featured in this image postmarked on July 6, 1910. The message states that he "arrived today".

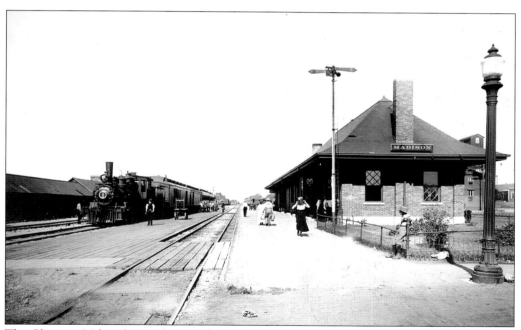

The Chicago, Milwaukee and St. Paul Depot and Railroad Yards in Madison, Lake County are shown in this card postmarked May 27, 1920. The message is "arrived OK".

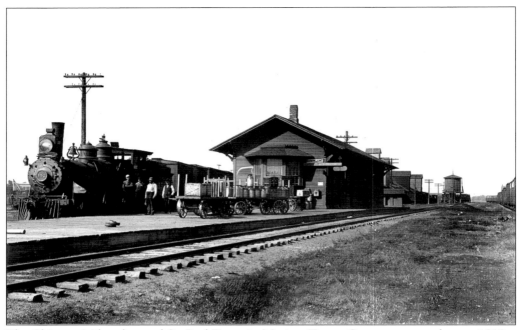

The Chicago, Milwaukee and St. Paul Depot in Marion, Turner County, are seen here *c.* 1910.

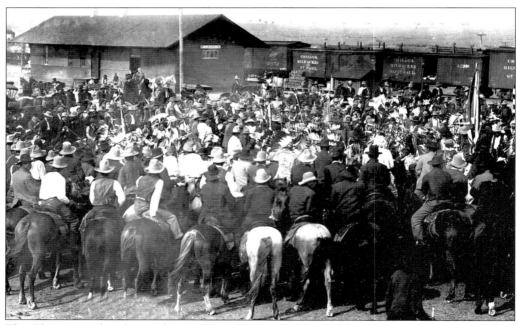

The Chicago, Milwaukee and Puget Sound Depot in McLaughlin, Corson County, *c.* 1910, is pictured here, as a Sioux Indian Dance is being held.

As an inducement to build railroads in unsettled areas, railroads companies were given alternating sections of land along the tracks by the government. This is an 1899 receipt for a deed of land in the White Rock, Roberts County area from the St. Paul, Minneapolis and Manitoba Railroad that was then part of the Great Northern Railroad.

8-98 1M RP Form 2312 Copying Ink

J. E. Oscarson No. 8578.

St. Paul, Minneapolis & Manitoba Railway Co.
LAND DEPARTMENT.

St. Paul, _____4/16_____ 1899

Christina E. Johnson
White Rock N.D.

Dear Sir:

Herewith is handed you

Trustees Deed No. 18480 , executed in your favor for the

Part of Section	Sec.	Town	Range
Lot 2	3	128	47

You will oblige me by signing this card and placing it in the post office.
Yours truly,

LAND COMMISSIONER.

Received above Jan 26 1899

(Sign here) J. E. Oscarson

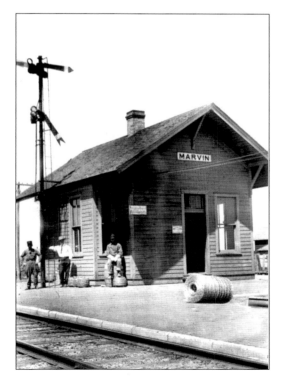

The Chicago, Milwaukee and St. Paul Depot in Marvin, Grant County is seen here in this card postmarked May 17, 1912.

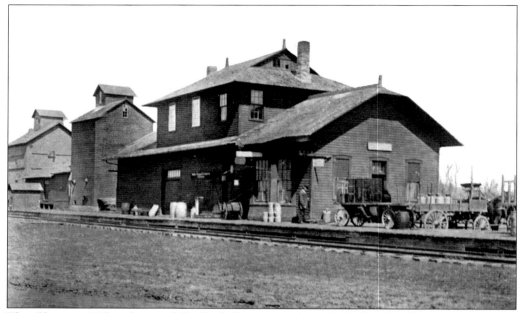

The Chicago, Milwaukee and St. Paul Depot and the John J. Decker elevator in Menno, Hutchinson County are visible in this image postmarked June 7, 1911. (Courtesy of Sonny Decker.)

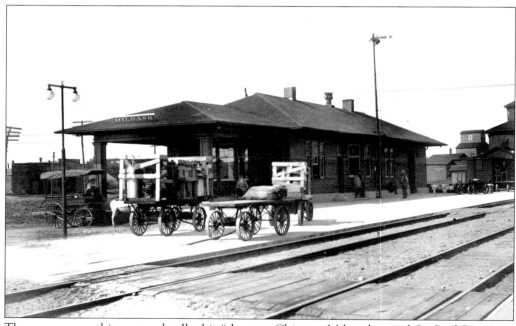

The message on this postcard calls this "the new Chicago, Milwaukee and St. Paul Passenger Depot—very up-to-date and complete." in Milbank, Grant County, c. 1908.

The Chicago, Milwaukee and St. Paul Depot and Railroad Yards in Milbank, Grant County are visible in this picture postcard which was sent on August 30, 1910.

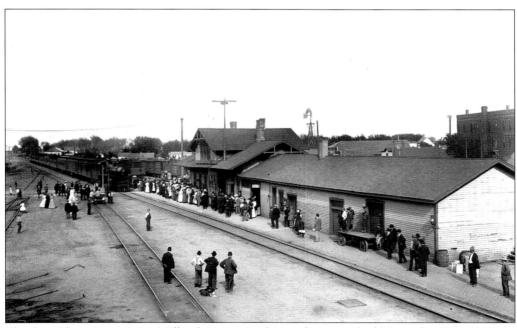

The first Olympian train in Milbank is seen in this card, postmarked November 20, 1911.

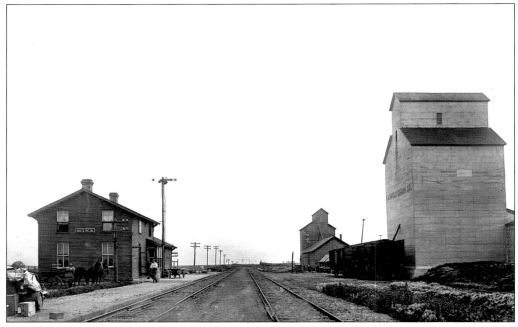

The Chicago, Milwaukee and St. Paul Depot in Mina, Edmunds County is visible in this image postmarked August 18, 1915.

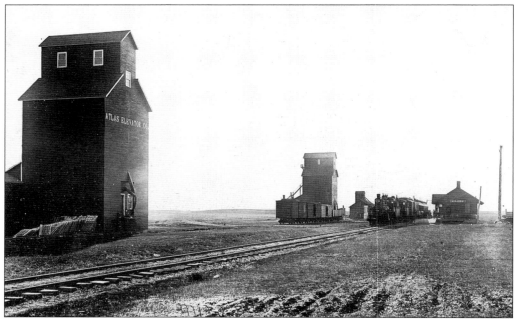

The Chicago and North Western Depot and elevators in Miranda, Faulk County, are seen here *c*. 1910.

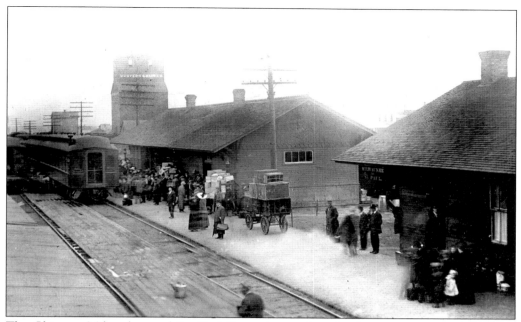

The Chicago, Milwaukee and St. Paul Depot is seen here landing passengers in Mobridge, Walworth County. This image was sent on July 20, 1912.

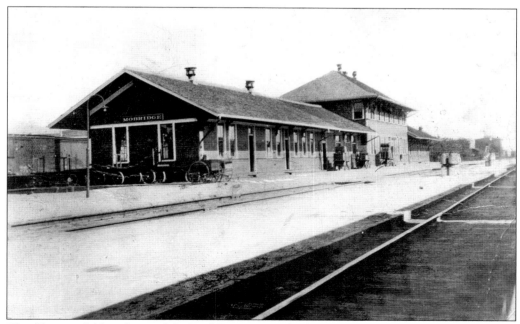

The Chicago, Milwaukee and St. Paul Depot in Mobridge, is pictured here *c.* 1910.

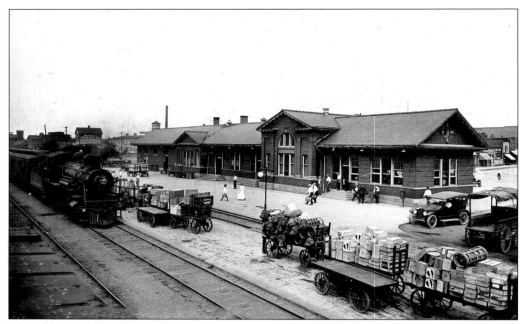

The Chicago, Milwaukee and St. Paul Depot and Railroad Yards in Mitchell, Davidson County, are seen here *c.* 1920.

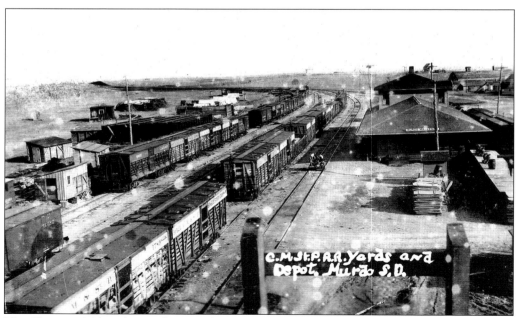

The Chicago, Milwaukee and St. Paul Depot and Railroad Yards at Murdo, Jones County are seen in this picture postcard sent June 4, 1908.

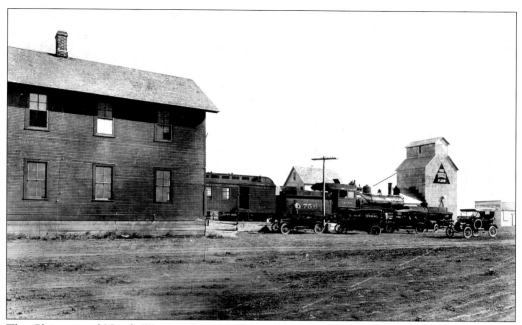

The Chicago and North Western Depot in Newell, Butte County, is shown here *c.* 1912.

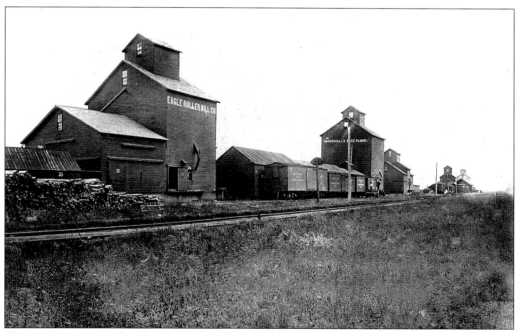

Elevator Row in Northville, Spink County, with the Chicago and North Western Depot in the distance, is visible here *c.* 1907.

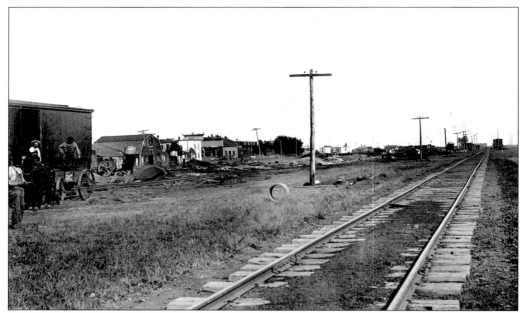

The Chicago, Milwaukee and St. Paul tracks arriving in Oldham, Kingsbury County, can be seen with the depot at the far end of the picture. The postmark on this card is September 21, 1911.

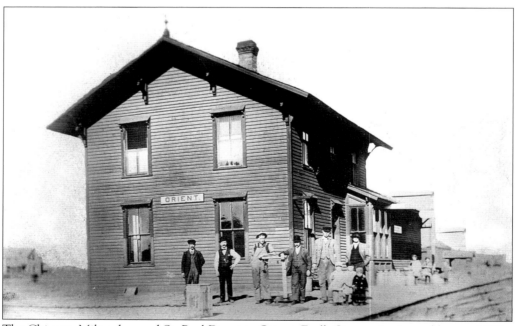

The Chicago, Milwaukee and St. Paul Depot in Orient, Faulk County, is pictured here *c.* 1910.

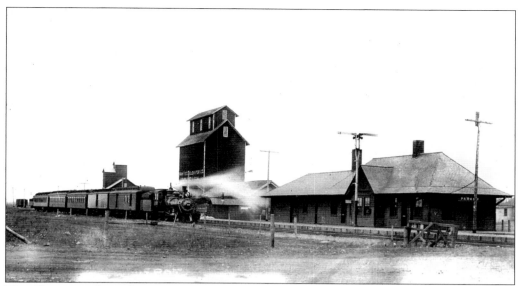

The Chicago and North Western Depot in Parker, Turner County, is pictured here *c.* 1910.

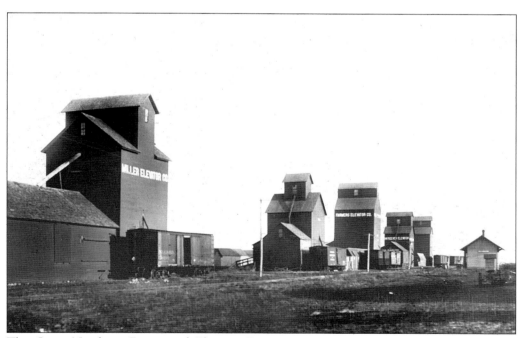

The Great Northern Depot and Elevator Row in Peever, Roberts County is seen in this postcard, which was sent on August 2, 1917.

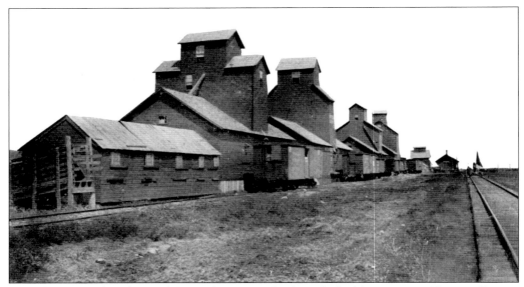

The Chicago, Milwaukee and St. Paul Depot is the far right building, next to Elevator Row in Pierpont, Day County. This image is postmarked August 14, 1908.

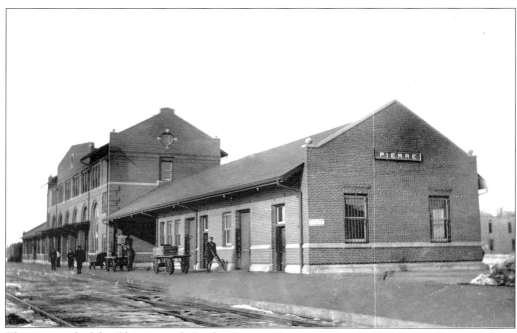

This postcard of the Chicago and North Western Depot and Freight Building in Pierre, Hughes County was sent on February 19, 1910.

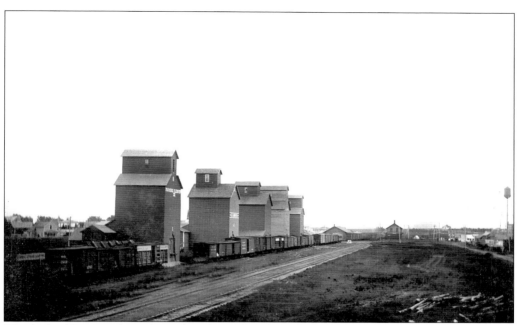

The far building on the right is the Chicago, Milwaukee and St. Paul Depot at the end of the Elevator Row in Platte, Charles Mix County, *c.* 1910.

This postcard of the Chicago, Milwaukee and St. Paul Depot and Elevator Row in Pollock, Campbell County, was sent in 1915.

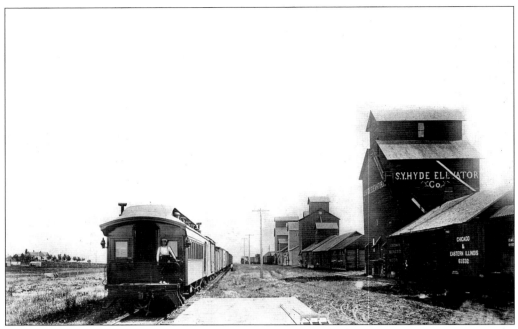

The Chicago, Milwaukee and St. Paul Railroad Yards and Elevator Row in Ramona, Lake County, are pictured here *c.* 1908.

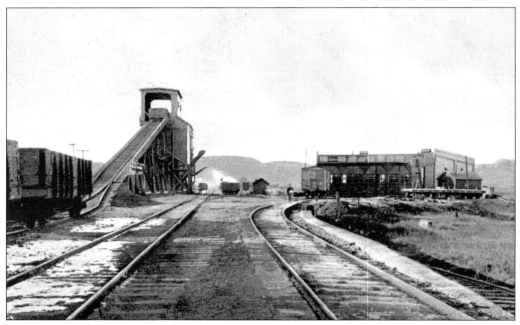

This image of the Chicago and North Western round house and coaling station in Rapid City, Pennington County was sent on February 20, 1911.

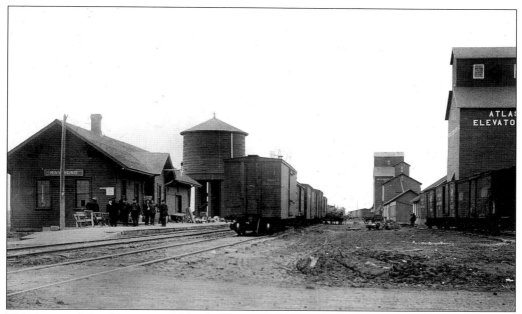

This image of the Chicago and North Western Depot and Railroad Yards in Raymond, Clark County was sent on May 23, 1910.

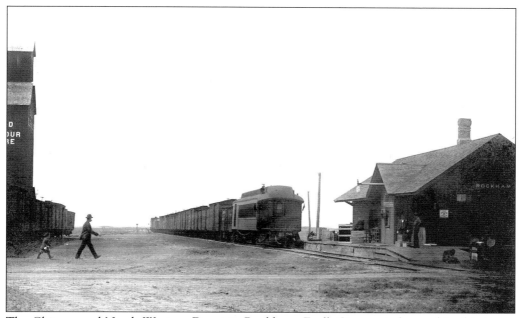

The Chicago and North Western Depot in Rockham, Faulk County, is featured in this image postmarked July 25, 1908.

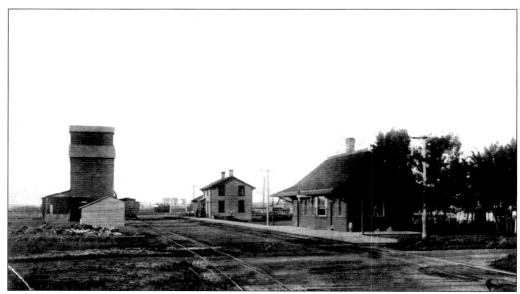

The old Chicago, Milwaukee and St. Paul Depot in Redfield, Spink County, is seen here *c.* 1910.

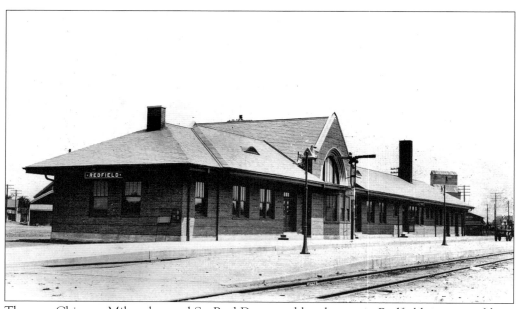

The new Chicago, Milwaukee and St. Paul Depot and lunchroom in Redfield, is pictured here *c.* 1915.

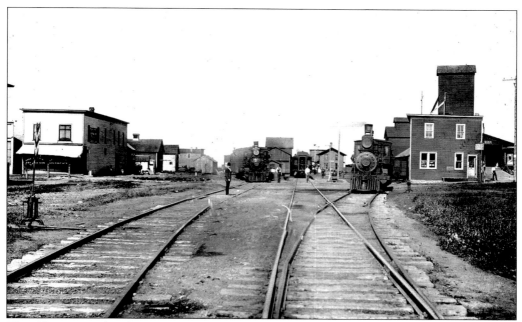

The Chicago, Milwaukee and St. Paul Railroad Yards with the depot in the right center in Roscoe, Edmunds County, is pictured here *c*. 1908.

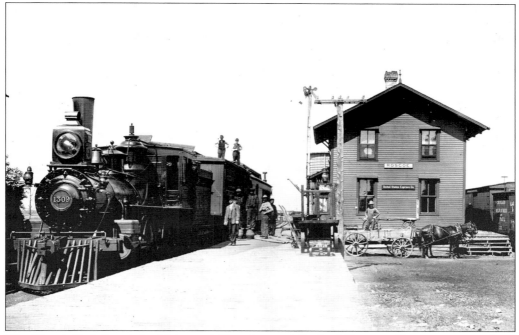

The "South Train" and the Chicago, Milwaukee and St. Paul Depot in Roscoe, are seen here *c*. 1908.

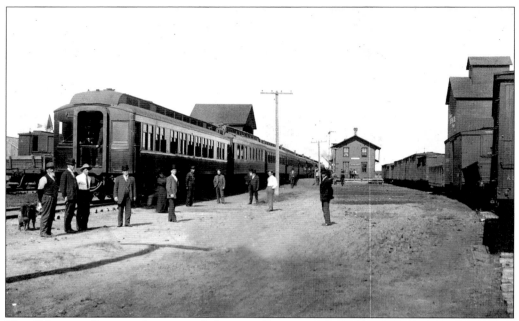

The "Morning Passenger" train and depot in Roscoe is featured in this image postmarked July 7, 1908.

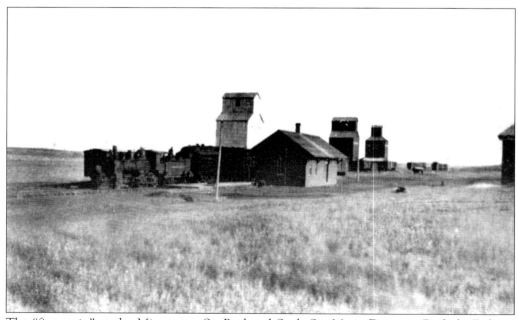

The "first train" at the Minnesota, St. Paul and Sault Ste Marie Depot in Rosholt, Roberts County, came through on November 12, 1913.

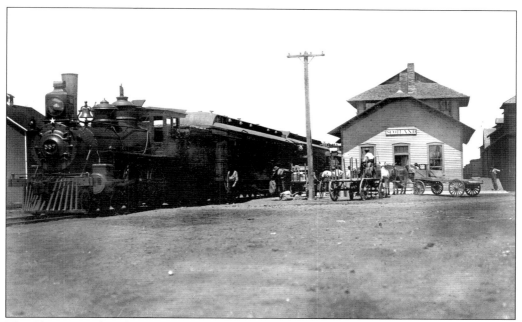

The Chicago, Milwaukee and St. Paul Depot in Scotland, Bon Homme County, is seen in this postcard sent August 29, 1910.

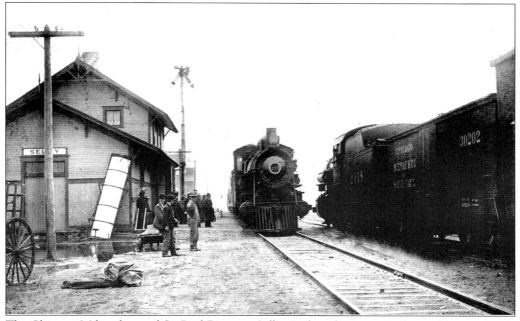

The Chicago, Milwaukee and St. Paul Depot in Selby, Walworth County, is featured here *c.* 1910.

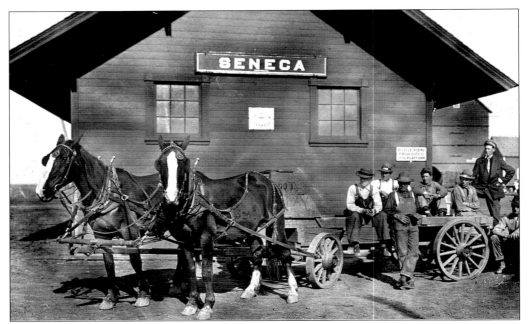

This is the Chicago and North Western Depot in Seneca, Faulk County. The sign at right says "Bicycle Riding Prohibited on this Platform". The postmark is May 25, 1910.

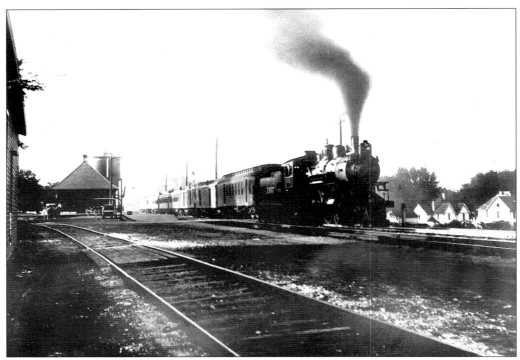

The Railroad Yards in Sioux Falls, Minnehaha County are seen in this picture postcard sent July 4, 1907.

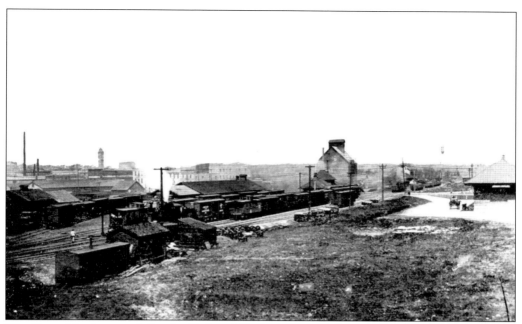

The Great Northern and Omaha Railroad Yards in Sioux Falls with the depot on the right, is seen here. This card was sent on May 13, 1911.

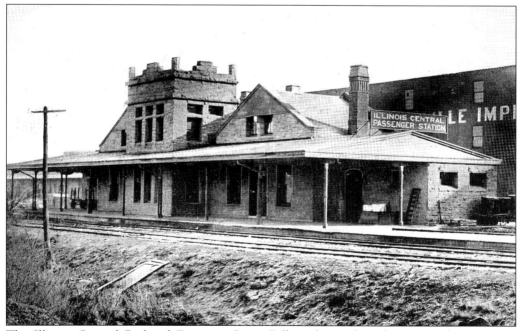

The Illinois Central Railroad Depot in Sioux Falls is featured in this postcard image sent June 7, 1910.

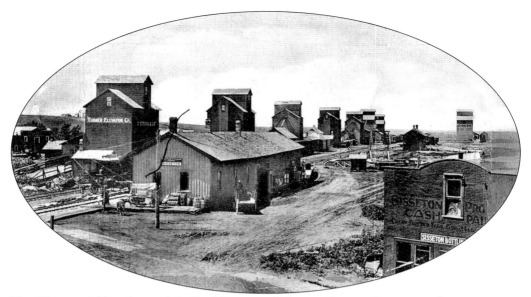

The Chicago, Milwaukee and St. Paul Depot and Elevator Row in Sisseton, Roberts County is seen here in this image sent November 21, 1912.

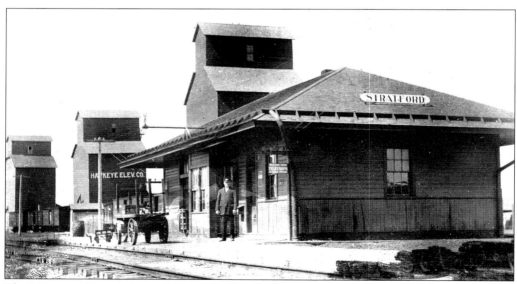

The Minneapolis and St. Louis Depot in Stratford, Brown County, is pictured here c. 1908.

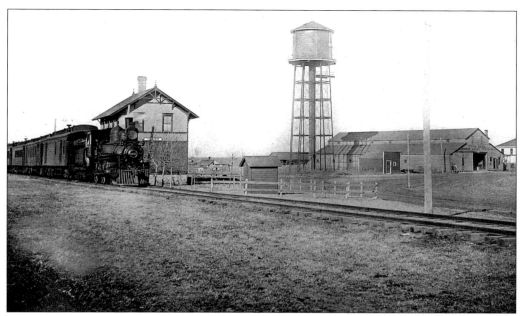

The Chicago, Milwaukee and St. Paul Depot in Tabor, Bon Homme County is featured in this postcard image sent December 15, 1909.

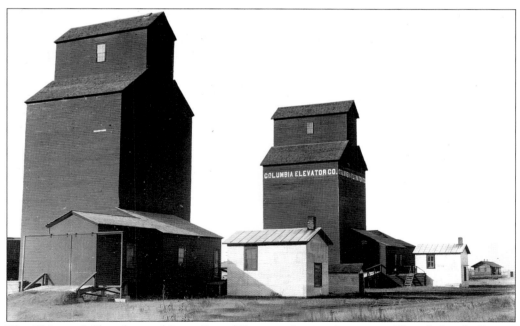

The Chicago, Milwaukee and Puget Sound Depot and grain elevators in Thunderhawk, Corson County, is pictured here *c.* 1915.

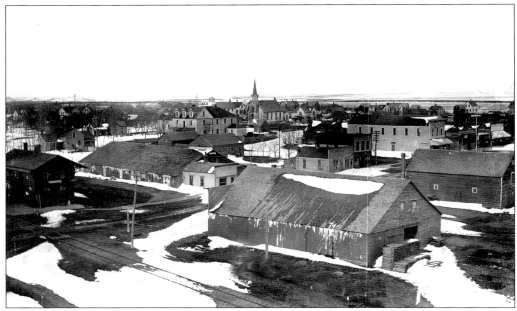

The Chicago, Rock Island and Pacific Depot and aerial view of Toronto, Deuel County, is visible in this postcard sent May 17, 1907.

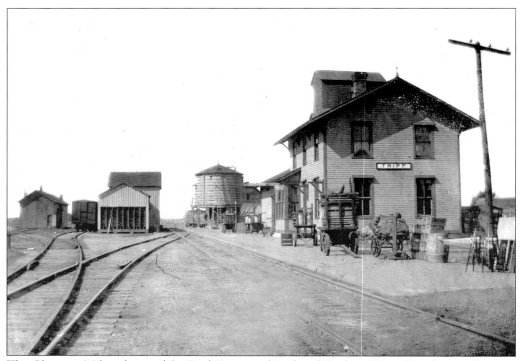

The Chicago, Milwaukee and St. Paul Depot and Railroad Yards in Tripp, Hutchinson County, can be seen in this postcard sent May 14, 1908.

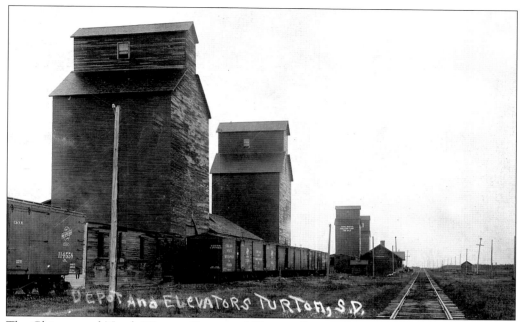

The Chicago and North Western Depot and Elevator Row in Turton, Spink County, featured here in this image postmarked September 21, 1915.

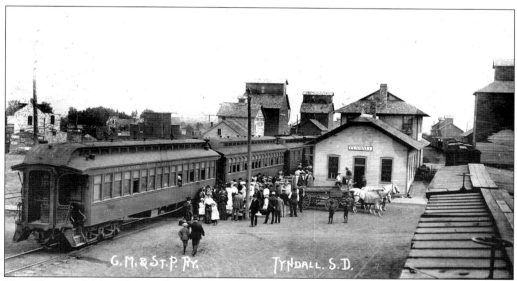

The Chicago, Milwaukee and St. Paul Depot in Tyndall, Bon Homme County, featured here and postmarked May 4, 1908. The sender is looking for someone to exchange postcards with in New York.

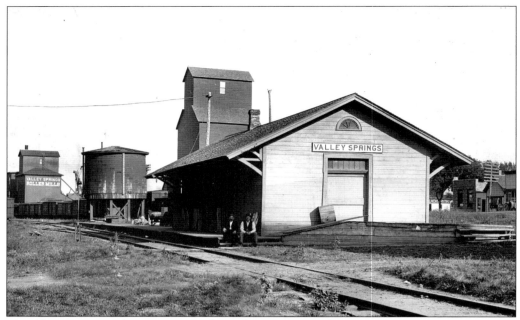

The Chicago, St. Paul, Minnesota and Omaha Depot in Valley Springs, Minnehaha County, is featured in this image, copyrighted 1909.

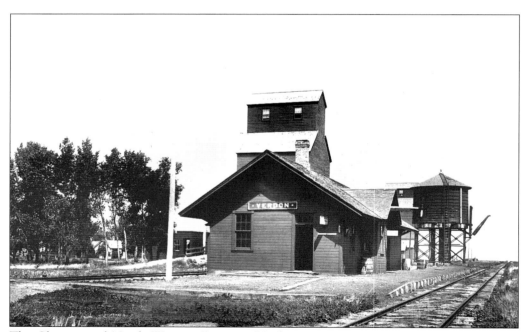

The Chicago and North Western Depot in Verdon, Brown County, seen here in an image postmarked December 18, 1916. The message states that they had "just reached Verdon OK".

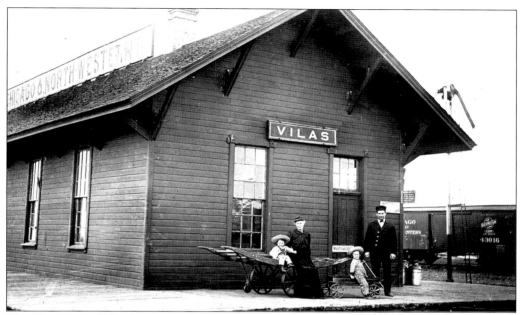

The Chicago and North Western Depot in Vilas, Miner County, pictured here *c.* 1912.

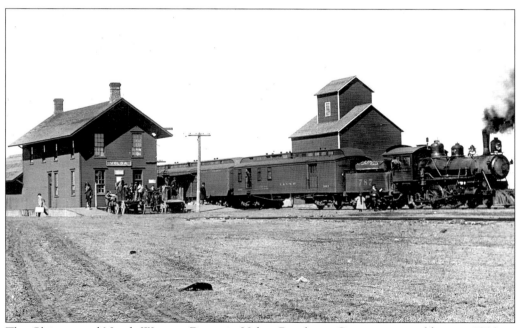

The Chicago and North Western Depot in Volga, Brookings County, pictured here *c.* 1910.

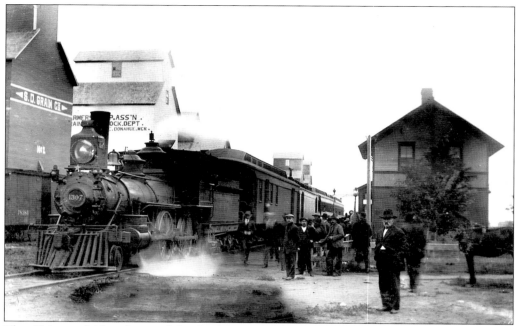

The Chicago, Milwaukee and St. Paul Depot and Railroad Yards in Wagner, Charles Mix County, pictured in this image copyrighted 1909.

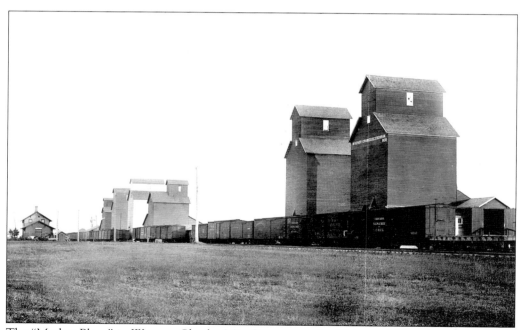

The "Market Place" in Wagner, Charles Mix County, on the Chicago, Milwaukee and St. Paul Railroad is seen above. The depot is on the far left. This postcard is copyrighted 1909.

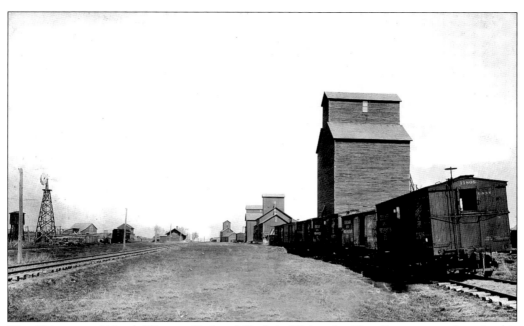

The Chicago and North Western Railroad Yards in Wakonda, Clay County, seen here in this image postmarked July 28, 1910.

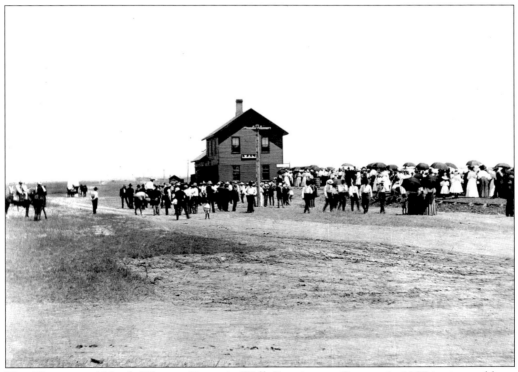

The Chicago and North Western Depot in Wall, Pennington County, in 1907 is pictured here as bystanders wait for the first train to arrive.

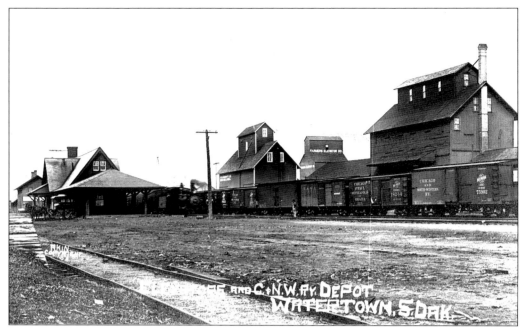

The Chicago and North Western Depot in Watertown, Codington County, is featured in this postcard sent on June 12, 1909. (Courtesy of Darrin Holien.)

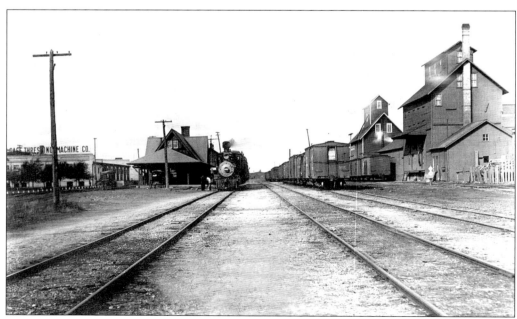

The Chicago and North Western Railroad Yards and Depot in Watertown are pictured here *c.* 1910. (Courtesy of Darrin Holien.)

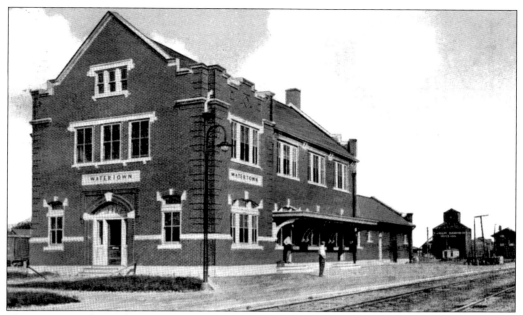

The Minneapolis and St. Louis Depot in Watertown is featured in this image postmarked September 27, 1919. (Courtesy of Darrin Holien.)

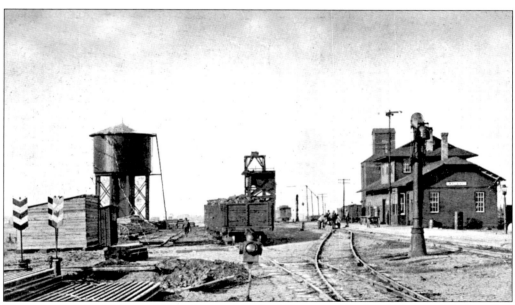

This image of the Chicago, Milwaukee and St. Paul Depot and Railroad Yards in Waubay, Day County, was postmarked August 11, 1917. The message states that she "will come on the 5 o'clock passenger train".

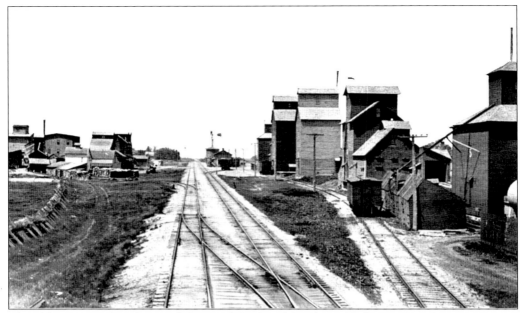

The Chicago, Milwaukee and St. Paul Railroad Yards in Webster, Day County, is seen above. The depot is in the far middle, just before the water tank. This card was postmarked November 21, 1912.

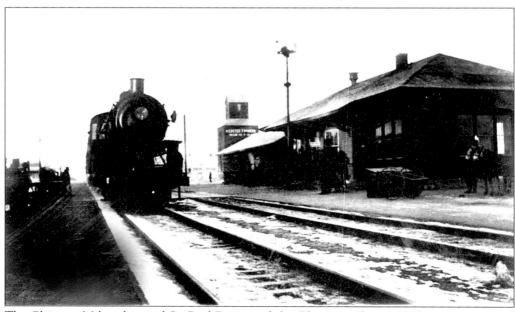

The Chicago, Milwaukee and St. Paul Depot and the Olympian Flyer in Webster, are pictured above *c.* 1912.

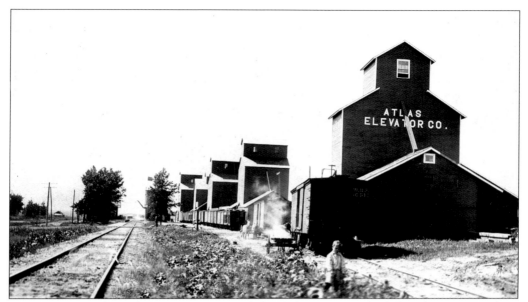

The Chicago and North Western Depot is behind the trees on the left and "Grain Market" elevators in Wessington, Beadle County. This image is postmarked September 29, 1909.

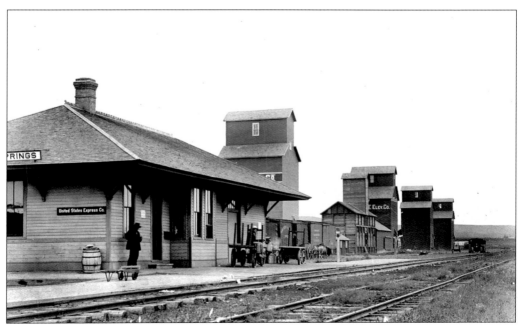

The Chicago, Milwaukee and St. Paul Depot and Elevator Row in Wessington Springs, Jerauld County, pictured above c. 1908.

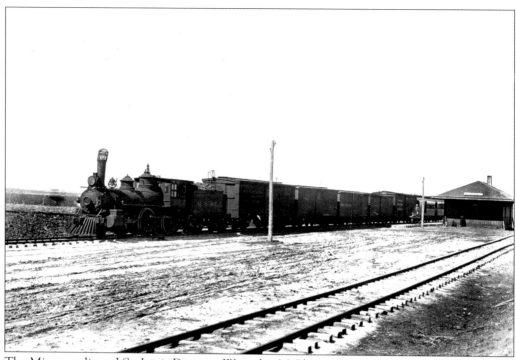

The Minneapolis and St. Louis Depot in Wetonka, McPherson County, pictured here *c.* 1910.

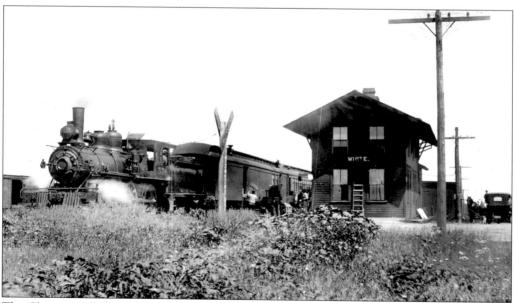

The Chicago and North Western Depot at "Train Time" in White, Brookings County, featured in this image postmarked October 13, 1914.

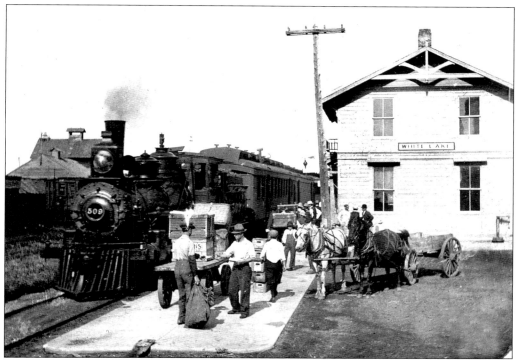

The Chicago, Milwaukee and St. Paul Depot in White Lake, Aurora County, is seen in this card postmarked September 21, 1911 with the message "I arrived safe and sound".

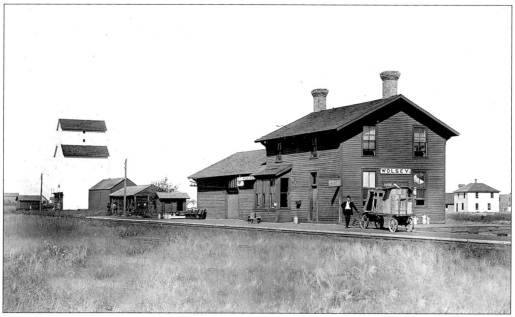

The Chicago, Milwaukee and St. Paul Depot in Wolsey, Beadle County, is seen in this image postmarked April 1, 1909 with message that "this is one of our elevators".

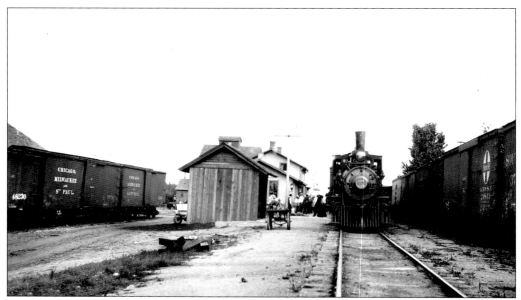

The Chicago, Milwaukee and St. Paul Depot in Woonsocket, Sanborn County, is seen in this postcard sent November 9, 1912.

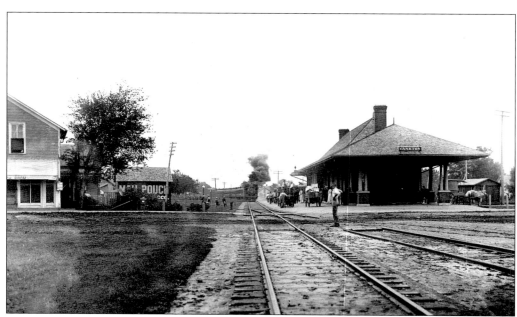

The Chicago, Milwaukee and St. Paul Depot in Yankton, Yankton County, featured here in this postcard sent June 30, 1910.

Two

TRAINS

This chapter deals with everyday life on the railroads and in the depots of various towns in South Dakota. Snow (and especially drifting snow) created problems in keeping the trains moving. There were many times that crews of 300 workmen with shovels were needed to clear the drifts that were just too large for the snowplows to handle. A stopped train halted everything else—both ways on the tracks. This chapter also shows the laying of tracks and the building of bridges, special events, stockyards, and shipping goods to market.

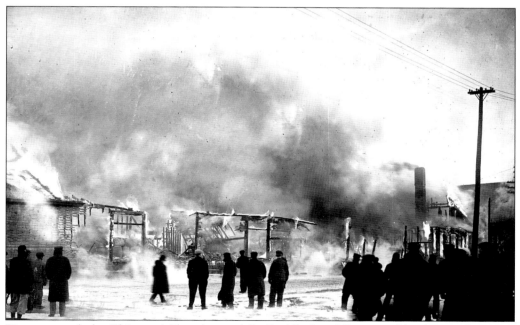

Disaster struck the Chicago, Milwaukee and St. Paul Railroad Depot in Aberdeen at 8 a.m. on January 23, 1911 when a fire destroyed the depot.

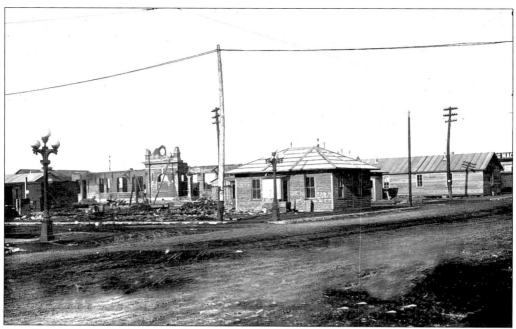

The fire was started when an oil stove exploded at 8 a.m. By noon, 15 carloads of workers arrived to start debris removal and to erect a temporary depot that was opened for business at noon two days later.

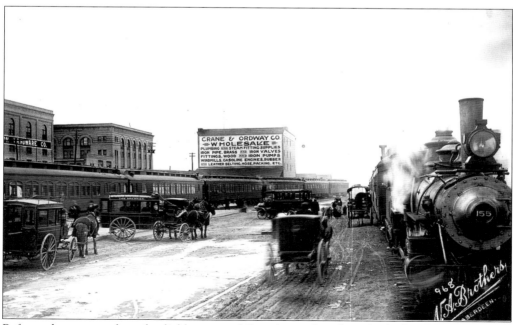

Before adequate roads and reliable automobiles, the preferred method of transportation was train. This view of the Aberdeen Railroad Yards shows the "buses" of local hotels on March 20, 1912. The bus in the far center is the only one not horse-drawn.

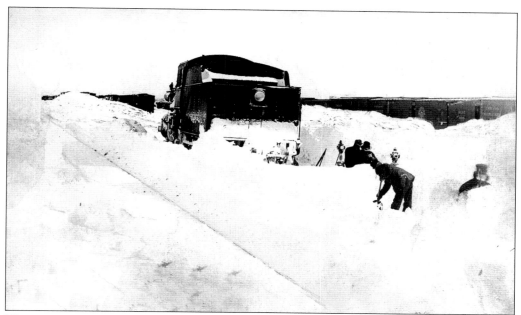

Wintertime snow and snowdrifts always meant more work and slower schedules as shown by this February 16, 1910 postcard in Aberdeen.

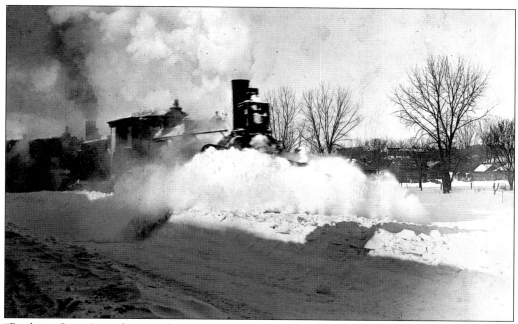

"Bucking Snow" or clearing the tracks in Canton on February 10, 1909 with a "V" shaped snowplow is illustrated above.

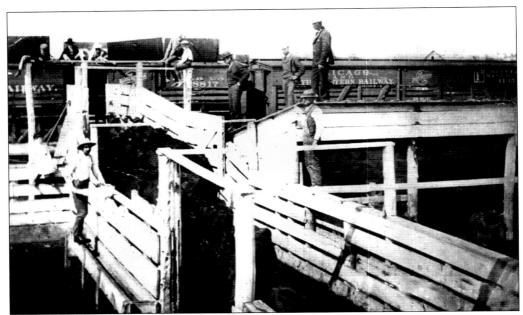

Cattle Stockyards in Carthage, Miner County, are visible here in this card sent July 10, 1909. Railroads were more than just trains and depots. They were necessary for economic survival and made the settling of the west possible, transporting farm products to the east and returning with merchandise and equipment.

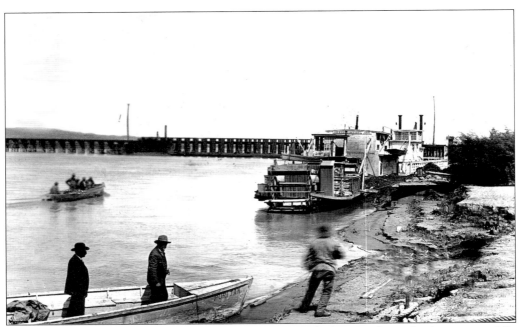

At one time, the only way to cross the Missouri River was by boat, as shown by these two paddle wheelers. Later, the railroads built bridges, like this Chicago, Milwaukee and St. Paul Bridge at Chamberlain, Brule County.

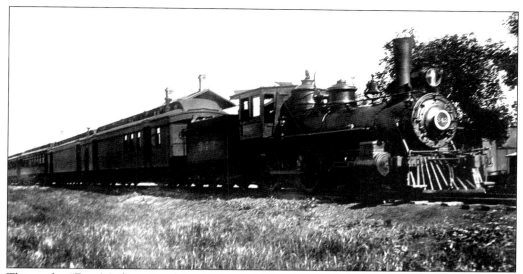

This is the "Fast Mail" train of the Chicago, Milwaukee and St. Paul Railroad going through Coleman, Moody County, *c.* 1910. Before roads and airplanes, all mail was moved by rail and an elaborate system of Railway Post Offices (RPO's) was in operation to sort and move the mail.

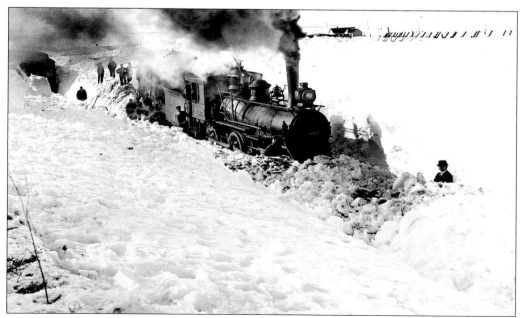

This Chicago and North Western train is stalled in a snowdrift in Dallas, Gregory County, because it is not equipped with a snowplow.

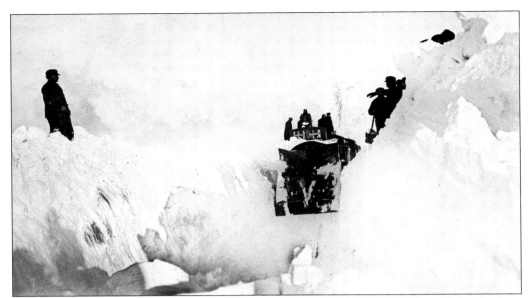

The winter of 1915 in Dallas, South Dakota saw huge snowdrifts some 15 to 20 feet high in places. Sometimes a snowplow wasn't enough and crews were used to hand shovel the snow off the tracks.

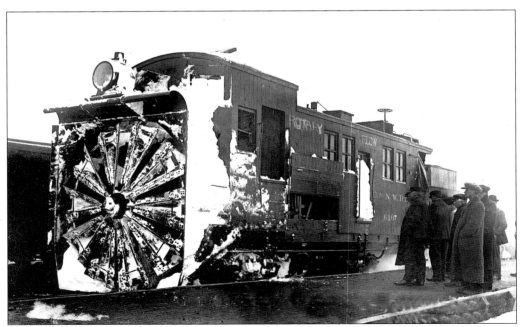

On February 19, 1915, the Chicago and North Western brought in a rotary snowplow to open the tracks in Dallas.

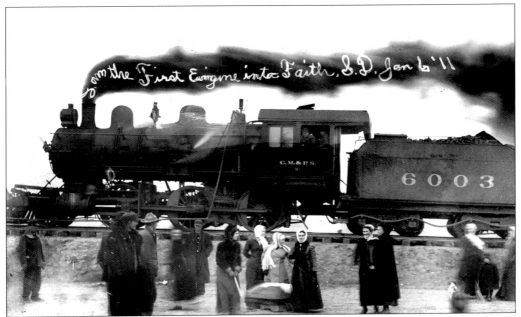

This is an interesting commercial postcard of the first Chicago, Milwaukee and Puget Sound train in Faith on January 6, 1911. The postmark is also January 6, 1911.

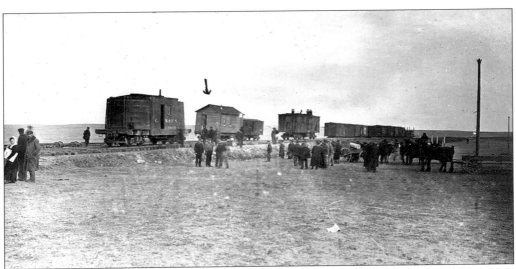

The arrow points to the Chicago, Milwaukee and Puget Sound Depot being hauled into Faith by Rail on January 9, 1911.

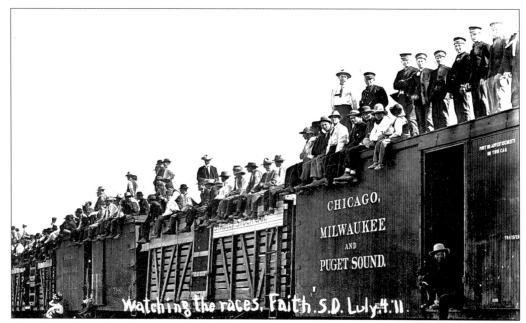

This image shows an unusual use of the boxcars of a train, serving as bleachers for the crowds watching the races on July 4, 1911 in Faith.

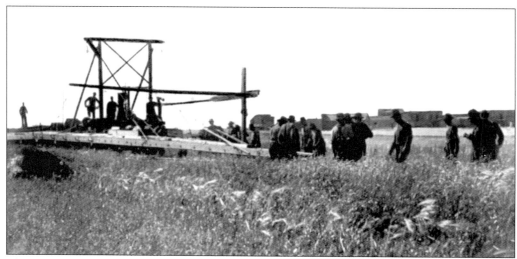

This image, *c.* 1908, features a track laying machine bringing the Minnesota and St. Louis tracks to Florence, Codington County. This postcard was published by the Dakota Town Lot Company that was selling land in the new town of Florence.

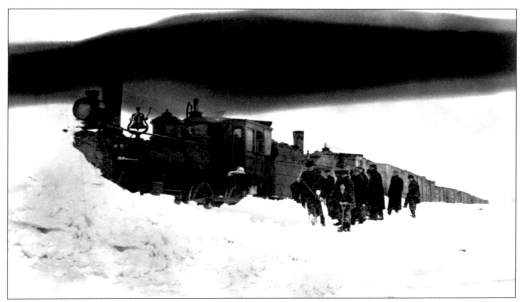

This is a freight train stuck in a snowdrift in Freeman, Hutchinson County, in 1915. They would either have to manually dig it out or back up to an open siding to allow a snowplow to get ahead of them. This is postmarked April 23, 1915.

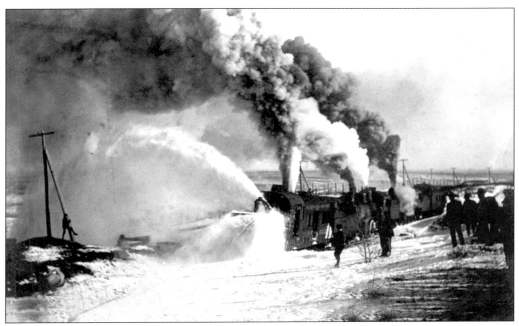

A rotary snowplow opening the Chicago and North Western tracks in Gary, Deuel County, is seen here. This rotary plow had its own engine that only ran the snowplow.

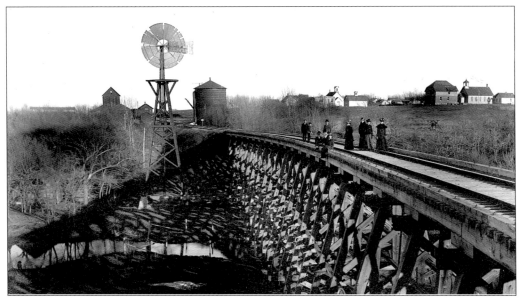

Railroads had to build bridges to cross rivers and streams like this Chicago and North Western bridge near Gary. It also served as a bridge for people to cross, however dangerous. This card is postmarked June 11, 1907.

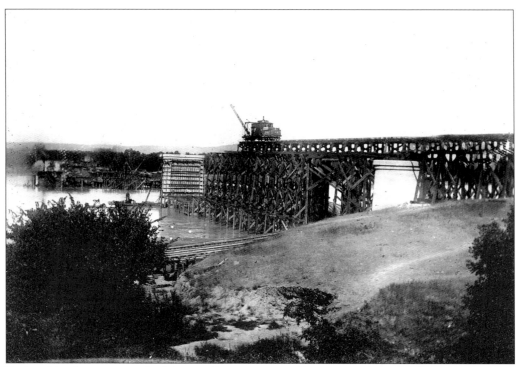

Railroad bridges crossing the Missouri River were usually over a mile in length and took a long time to build. This postcard is dated September 29, 1907 at Glenham, Walworth County, and titled "looking west showing the falsework".

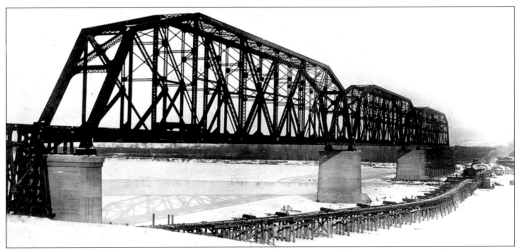

The Chicago, Milwaukee and St. Paul Bridge at Glenham "will be ready for service tomorrow thurs. 3/19/08 at 9:55 am Mountain Time". This image is postmarked March 18, 1908.

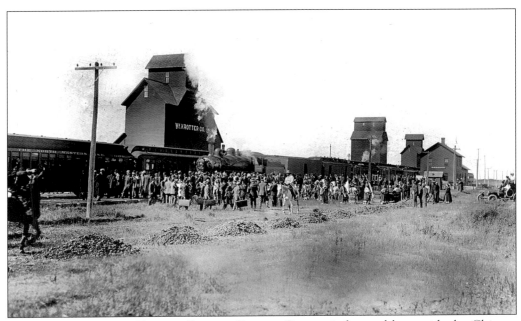

The 1914 Registration Train at Gregory, Gregory County, is featured here with the Chicago and North Western Depot in the background. In the center are Indians doing a War Dance in full costume.

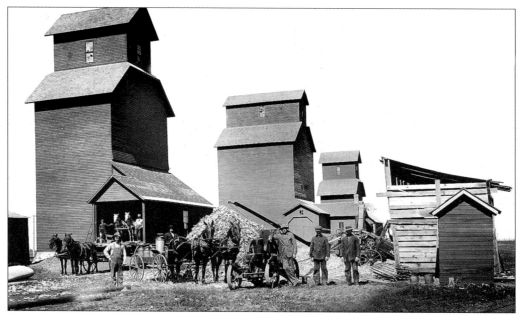

Grain elevators served as a central collecting point for farmers' crops and were always situated besides railroad tracks for loading convenience like these elevators in Herrick, Campbell County, on the Chicago, Milwaukee and St. Paul Railroad. This picture postcard was sent August 22, 1910.

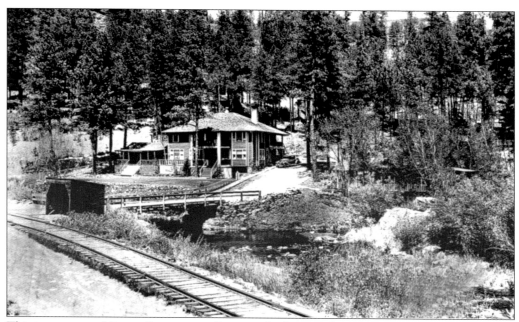

This is a resort at Hisega, Pennington County, which was only accessible by train as a stopping place between Rapid City and Mistic. The depot is actually an all-weather shelter for awaiting the train.

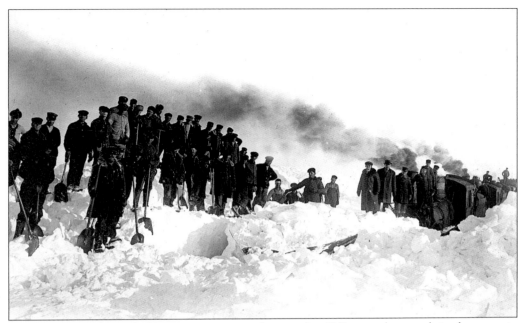

The Chicago and North Western train is seen here with a "V" snowplow stuck in the snow in Hodges, Butte County. It shows an entire crew of workmen with shovels. The town of Hodges only existed for 13 months from December 1910 to January 1912.

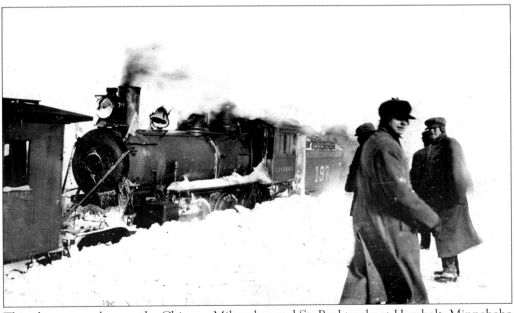

This photo was taken on the Chicago, Milwaukee and St. Paul tracks at Humbolt, Minnehaha County, on December 12, 1912. It shows one train behind another with people standing around wondering what to do.

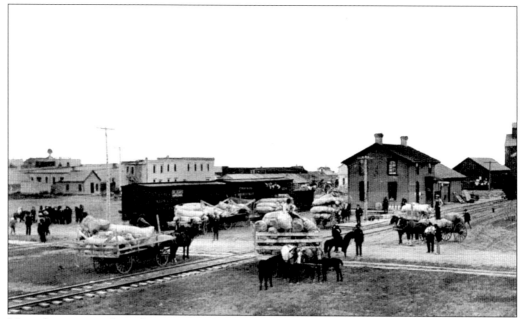

More than just cattle and grain were shipped via railroads as evidenced by this "Wool Shipping Day in Ipswich", *c.* 1910. Shippers learned to combine their shipments to make a full train carload to get the best deal on shipping.

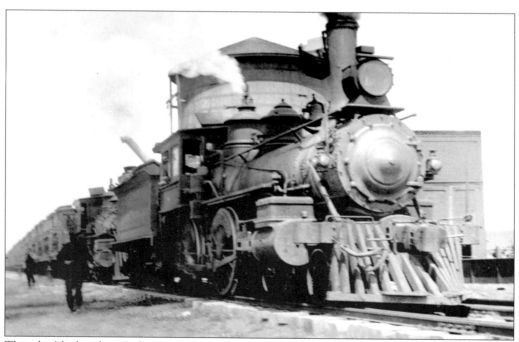

This double header stock train of the Minnesota and St. Louis is seen arriving in Lebeau, Walworth County, *c.* 1910. Lebeau marked the end point at the Missouri River of the Conde and Lebeau run.

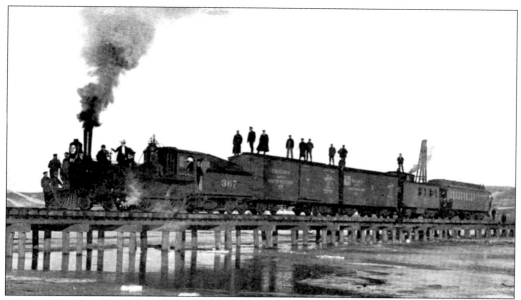

This was the first Chicago and North Western train to cross the Missouri River Bridge at Pierre, Stanley County. This card is postmarked November 15, 1907.

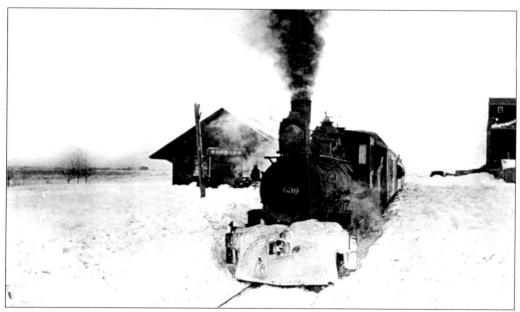

This Chicago and North Western train with a small snowplow stopped at the depot in Rockham, Faulk County, c. 1915.

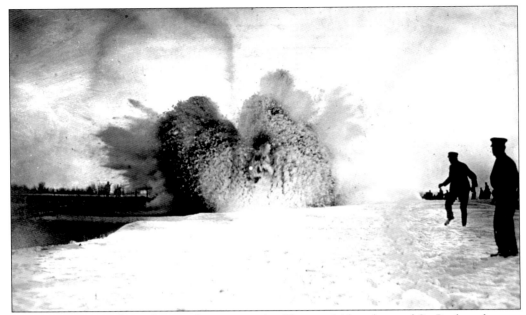

A snowplow is seen here clearing the snow on the Chicago, Milwaukee and St. Paul tracks near Scotland, Bon Homme County. This image was sent on March 2, 1909.

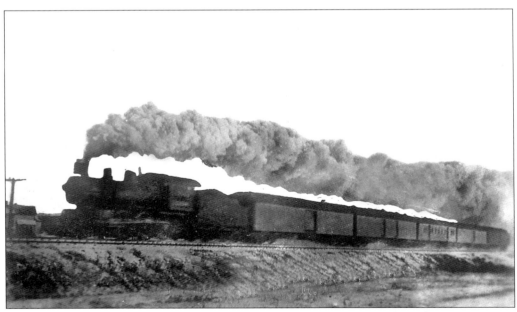

The Chicago and North Western "Fast Train" is pictured here going through Winner, Tripp County. The postmark is October 10, 1911.

Three

WRECKS

For the first 20 years of the 20th century, accidents took the life of one railroad employee per month, on average. This chapter shows many examples of train wrecks and derailments from 1907 to 1920. It's not that these accidents were caused by bad tracks or improper maintenance, but more likely by the heavy use of the tracks. Many towns had up to 22 trains pass through a day. Some accidents were human error and some were just accidents. People were hurt and lives were lost and timetables were thrown out of whack. After caring for the people, speed was necessary for clearing and repairing the tracks. Special salvage trains and crews were brought in to remove the debris.

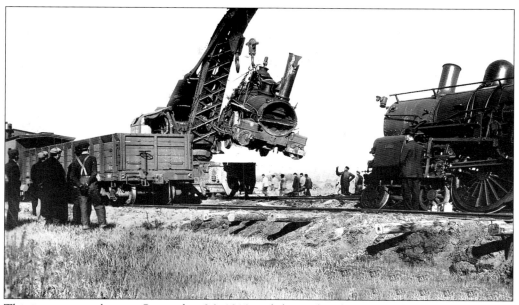

This image was taken on September 26, 1910 and shows the clean up of the head-on collision eight miles east of Aberdeen, Brown County. This postcard shows the raising of engine 1331.

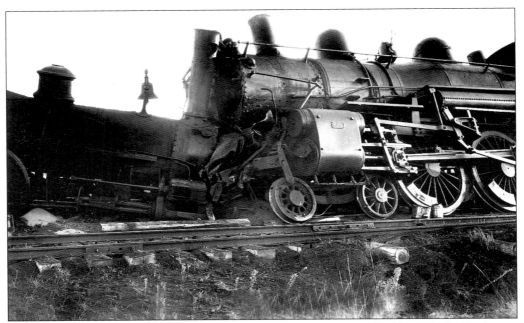

Pictured here is the September 27, 1910 wreck of the Chicago, Milwaukee and St. Paul train and a work train eight miles east of Aberdeen.

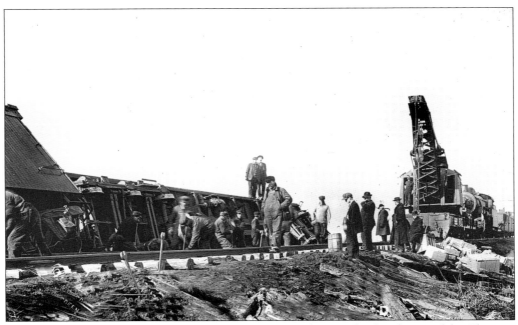

Taken on April 12, 1913, workers and observers are seen here at the derailment of the Chicago, Milwaukee and St. Paul Columbian Passenger train near Aberdeen.

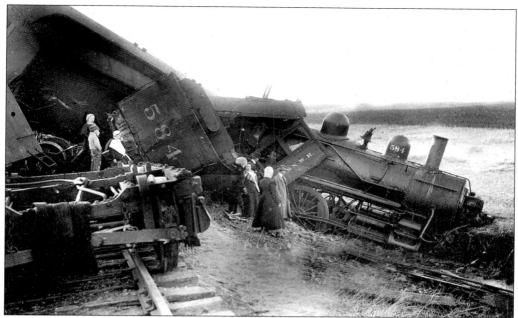

The April 5, 1913 wreck of the Chicago and North Western train and engine 584 near Arlington, Kingsbury County is seen here.

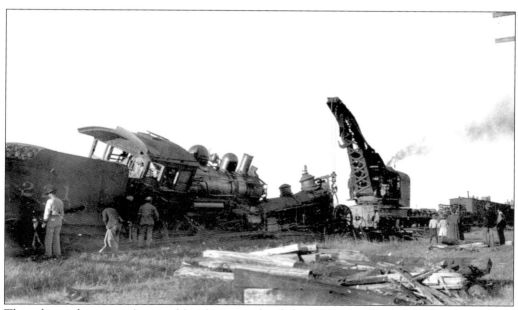

This photo shows an August 28, 1910, wreck of the Minneapolis and St. Louis at Bern, Brown County.

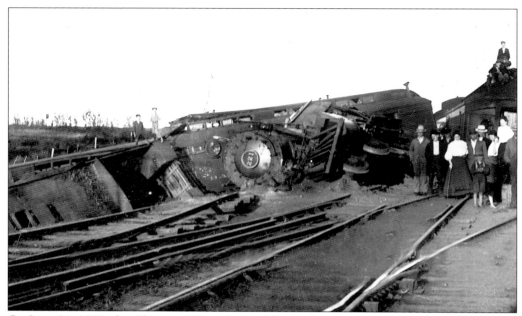

On June 24, 1908, the Chicago, Milwaukee and St. Paul and engine 221 crashed near Bristol, Day County.

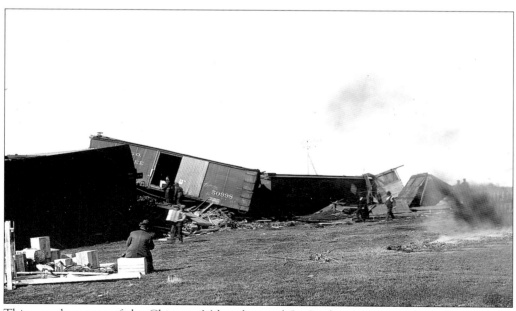

This was the scene of the Chicago, Milwaukee and St. Paul wreck near Bristol, Day County, on.April 16, 1912.

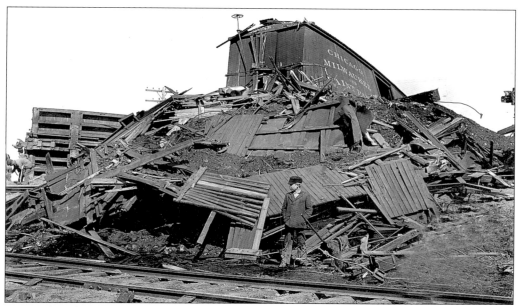

Again, this photo shows the image of the April 16, 1912 wreck of the Chicago, Milwaukee and St. Paul near Bristol, Day County.

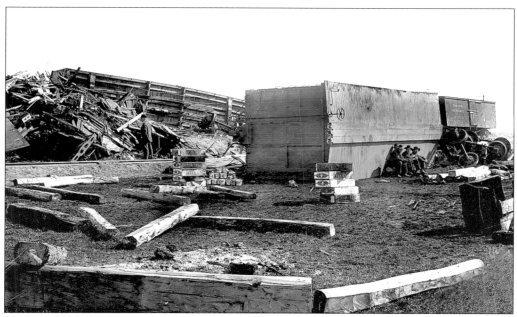

The April 16, 1912 scene of the Chicago, Milwaukee and St. Paul wreck near Bristol, Day County, featured above.

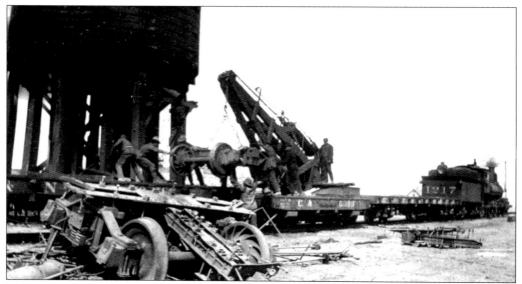

This image shows the April 14, 1908 scene of a big Chicago, Milwaukee and St. Paul train fire in the town of Broadland, Beadle County.

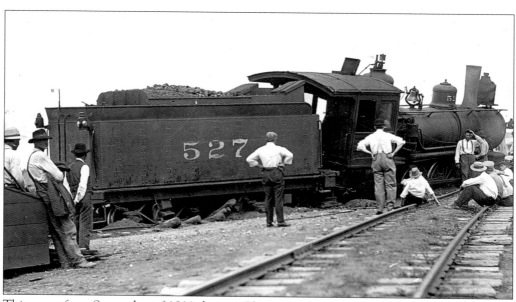

This scene from September of 1911 shows a Chicago and North Western train and engine 527 "in the ditch" at Centerville, Turner County. Postmark is September 28, 1911.

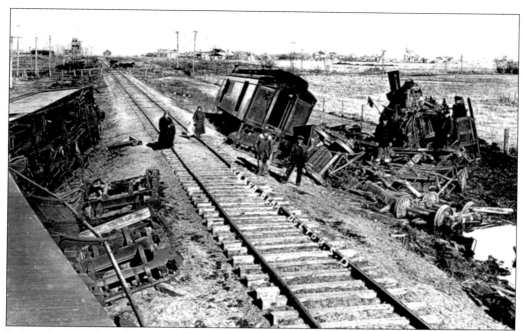

In March of 1916 the Chicago, Milwaukee and St. Paul train derailed after they "ran into some loose horses". Message also says, "a fireman was hurt" and that the "clean up train came from Mason, SD". This wreck occurred near Dolton, Turner County.

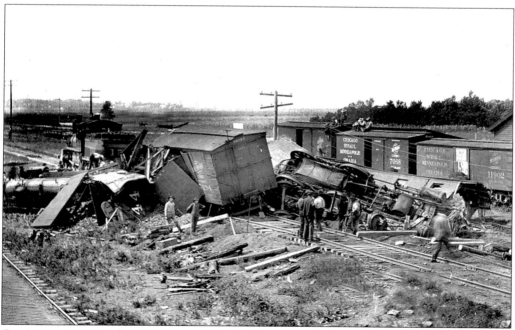

On August 9, 1907, the Chicago and North Western crashed near Elkton, Brookings County. It looks like it was engine 44.

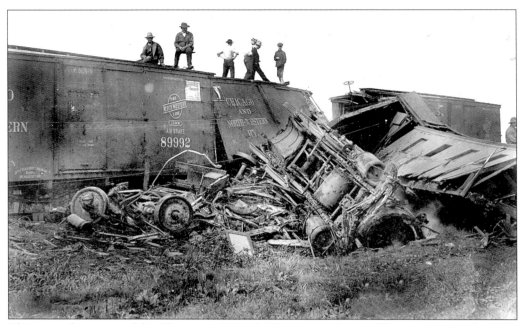

This is another scene of the Chicago and North Western wreck near Elkton on August 9, 1907.

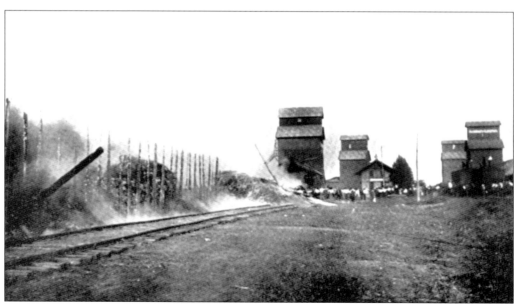

This September 3, 1908 image shows the burning of the elevators in the Chicago and North Western Railroad Yards in Flandreau, Moody County.

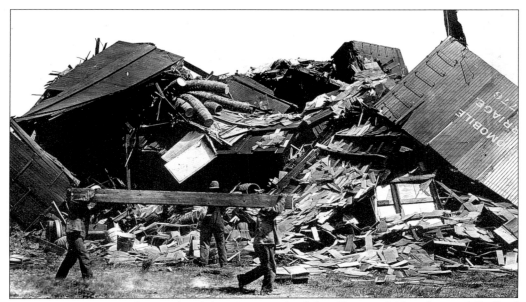

This image shows another angle of the 1912 wreck of the Chicago, Milwaukee and St. Paul between Ipswich and Beebe. The overturned car at right is for shipping automobiles by rail.

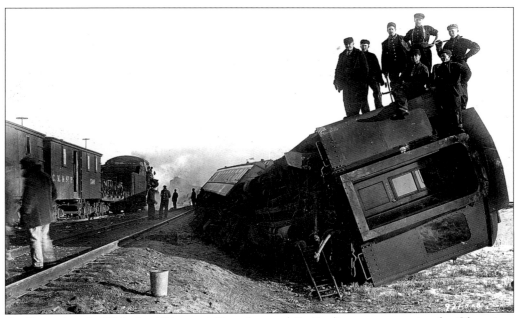

On December 6, 1911, the Chicago, Milwaukee and St. Paul's passenger train, the Olympian, crashed near Java, Walworth County.

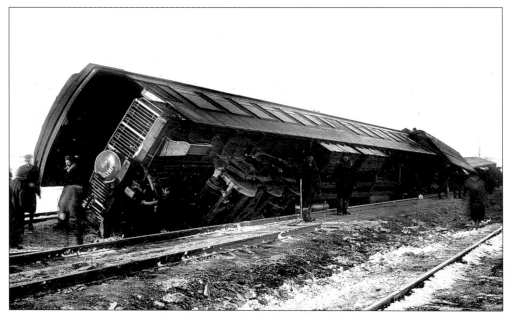

This is another scene of the December 6, 1911 wreck of the Chicago, Milwaukee and St. Paul's Passenger train, the Olympian, near Java.

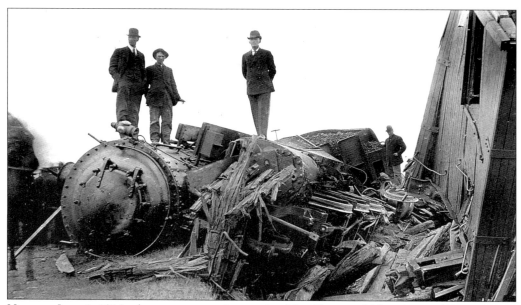

Here, on June 1, 1910, observers survey the wreck of the Chicago, Milwaukee and Puget Sound train wreck at Lemmon, Perkins County.

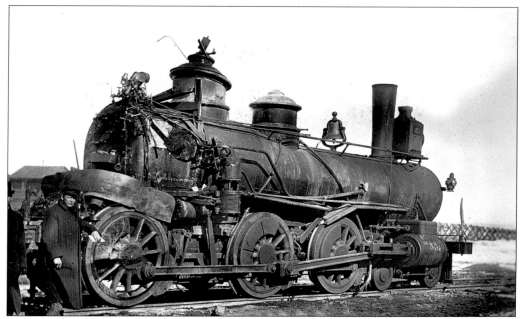

This *c.* 1912 image shows one of the two engines involved in a wreck of the Chicago, Milwaukee and Puget Sound trains near McIntosh, Corson County.

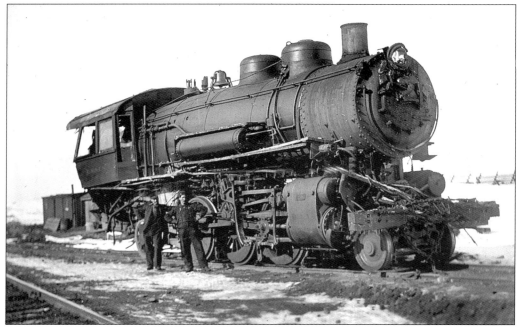

This *c.* 1912 image shows the other engine involved in the Chicago, Milwaukee and Puget Sound wreck near McIntosh.

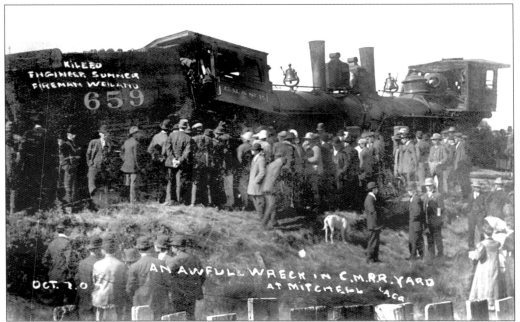

On October 7, 1907 there was an awful wreck in the Chicago, Milwaukee and St. Paul yard in Mitchell, Davidson County; Engineer Sumner and Fireman Weiland were killed.

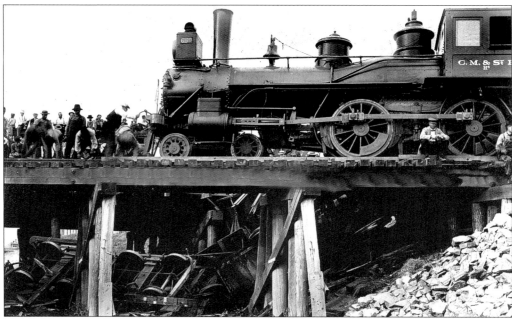

On September 12, 1908 the Chicago, Milwaukee and St. Paul had a wreck at a bridge in Mitchell. The message tells us that this is a switch engine on its back under the bridge.

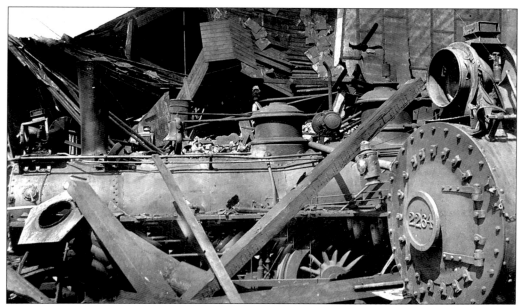

This September 5, 1916 image is titled, "Destruction of the Chicago, Milwaukee and St. Paul Roundhouse in Mitchell".

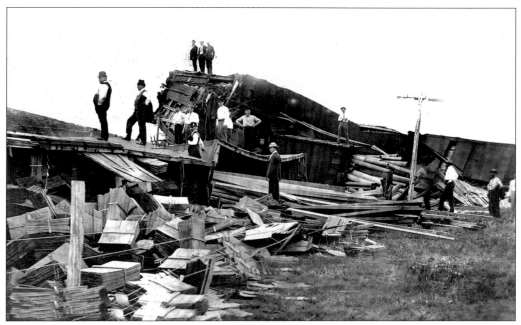

This is a May 1911 scene of the wreck of the Chicago, Milwaukee and St. Paul train in Mobridge, Walworth County.

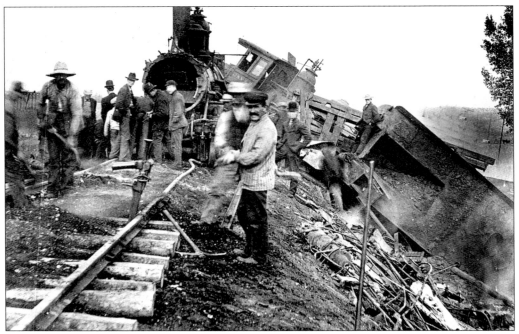

This October 4, 1908 image shows the wreck of the Chicago and North Western train near Parker, Turner County.

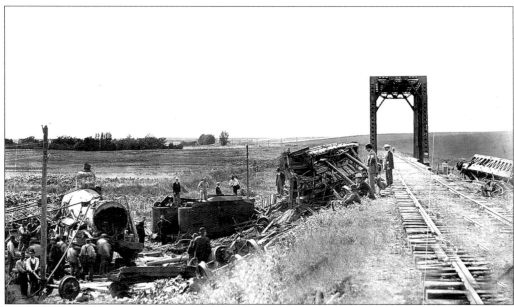

A Chicago and North Western train wreck near Parker, Turner County, is seen here on July 11, 1909.

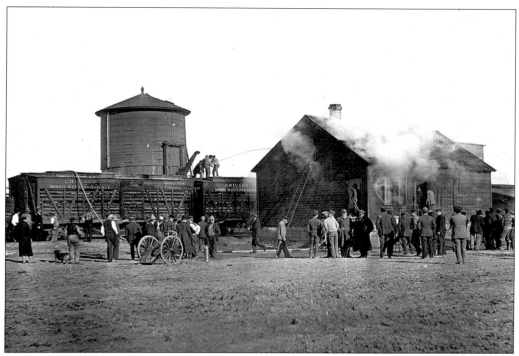

November 23, 1911 saw the seventh fire in Philip, Haakon County, this one in the Chicago and North Western Depot.

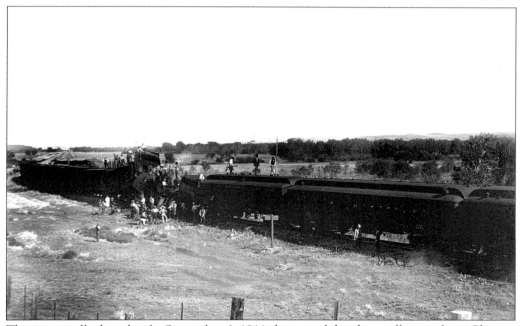

This image tells the tale of a September 6, 1911 slow-speed, head-on collision of two Chicago and North Western trains near Philip, Haakon County.

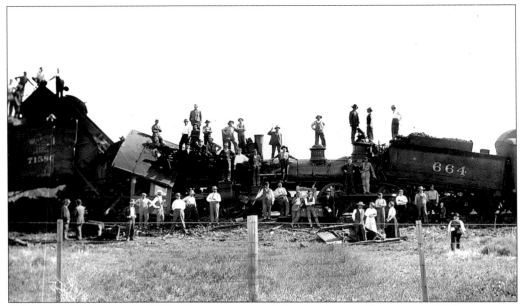

Taken on September 6, 1911, this is a view of the head-on collision near Philip between engines 527 and 664.

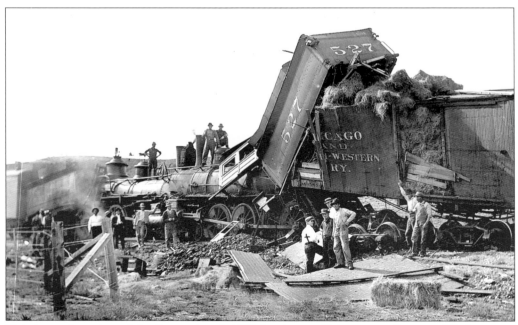

This is another view of the September 6, 1911 head-on collision one mile east of Philip.

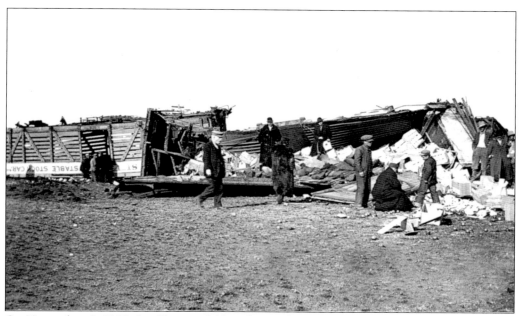

On November 6, 1912 the Chicago, Milwaukee and St. Paul train derailed four miles west of Roscoe, Edmunds County.

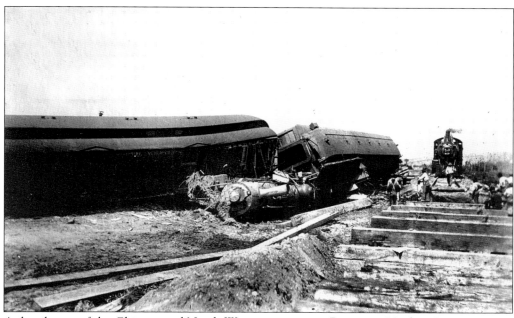

A derailment of the Chicago and North Western train near Rousseau, Hughes County, is seen here *c.* 1910.

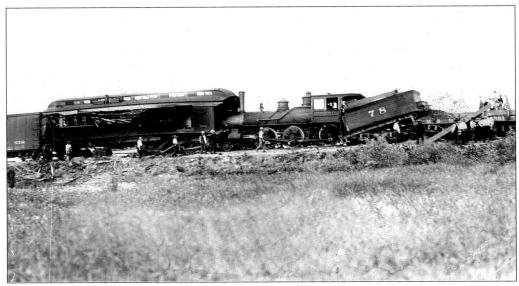

On July 21, 1909 there was a wreck in the Scotland, Bon Homme County, Railroad Yards when engine 78 ran into the back of another train.

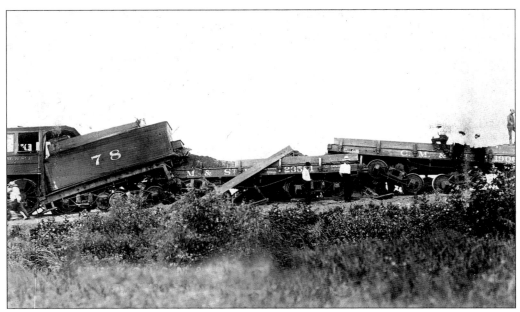

Also taken on July 21, 1909, this is another view of the cars behind engine 78 that rear-ended another train in the yards at Scotland.

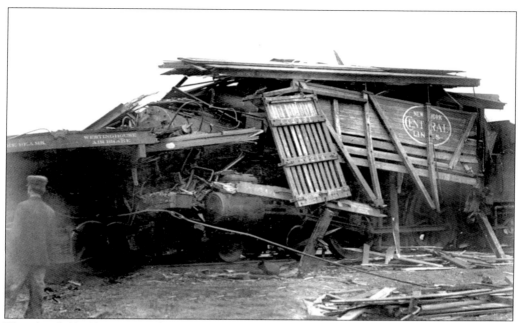

This April 12, 1910 image shows a wreck of the Chicago, Milwaukee and St. Paul train near Scotland, Bon Homme County.

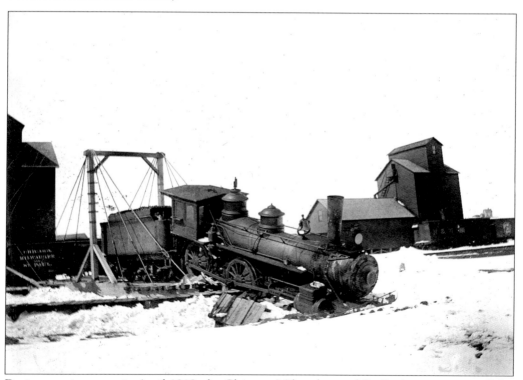

During a spring snow in April 1910, the Chicago, Milwaukee and St. Paul engine went off the tracks in Sisseton, Roberts County. The message is from one of the train's crew.

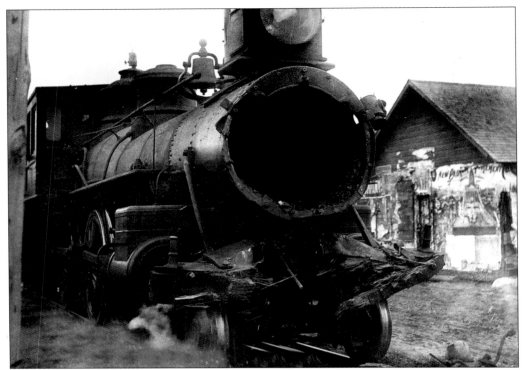

This image shows the April 5, 1907 wreck and derailment of the Chicago, Milwaukee and St. Paul train in the Railroad Yards in Vermillion, Clay County.

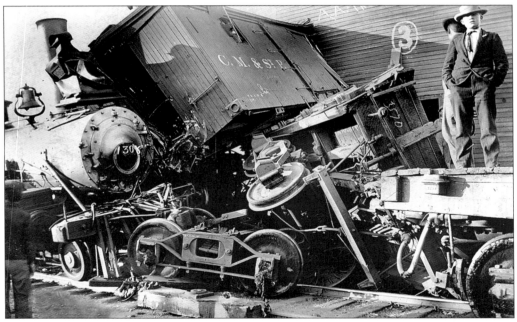

The October 12, 1907 wreck of engine 30 in the Railroad Yards in Vermillion, Clay County, are seen here.

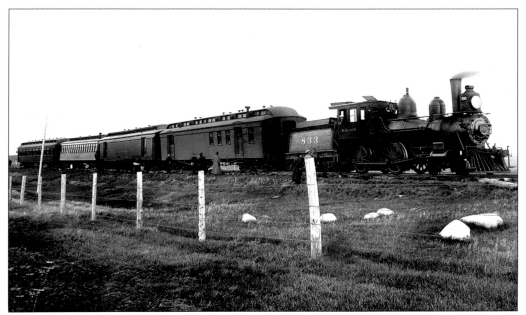

On May 15, 1912 a minor derailment of the Chicago and North Western engine 833 near Vilas, Minor County, occurred. Even minor accidents like this were a lot of work.

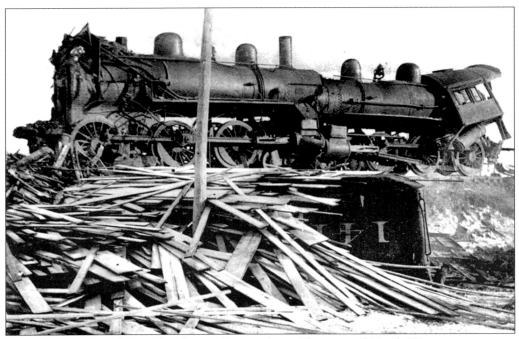

This *c.* 1910 image shows a head-on collision of two Chicago and North Western trains near Volga, Brookings County.

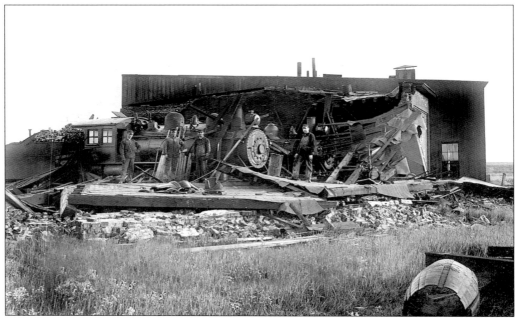

On June 23, 1914, a cyclone, also known as a Tornado, caused damage to this Chicago and North Western train, engine 326, near Watertown, Codington County.

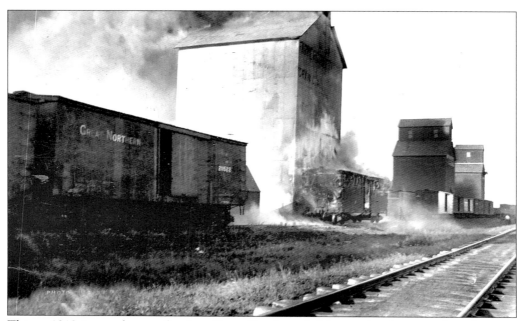

This *c.* 1912 image shows a fire in a Great Northern freight car that has spread to the grain elevator in Yale, Beadle County.